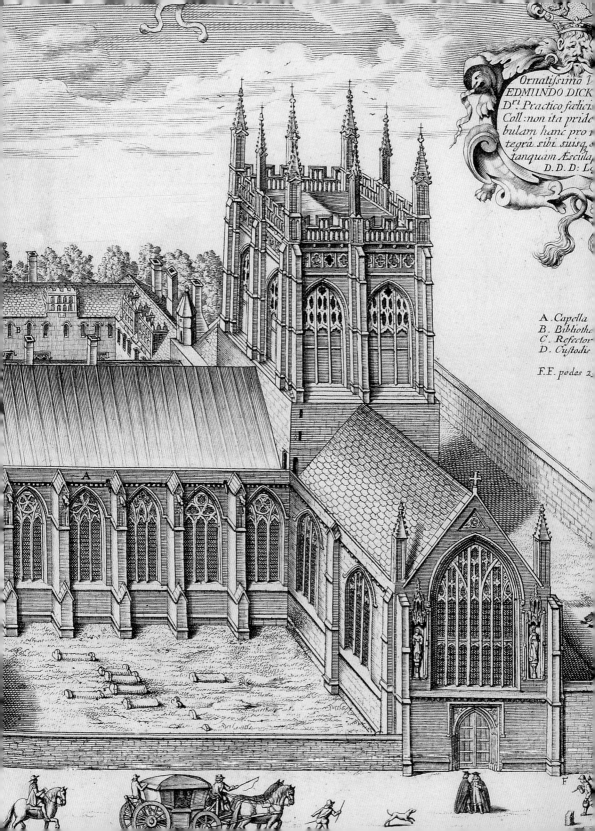

Ornatifsimo
EDMUNDO DICK
D[r]: Practico fælici
Coll: non ita pride
bulam hanc pro
tegrâ sibi suisq.
tanquam Æscula
D.D.D: L

A. Capella
B. Bibliothe
C. Refector
D. Cuftodis

F.F. pedes 2.

Merton College Library

An Illustrated History

JULIA C. WALWORTH

Bodleian Library
UNIVERSITY OF OXFORD

For the Merton College Guides,
past, present, and future.

First published in 2020 by the Bodleian Library,
Broad Street, Oxford OX1 3BG in association
with Merton College, Oxford
www.bodleianshop.co.uk

ISBN: 978 1 85124 539 0

Title page and inside back cover: The bird's-eye view of Merton
College published by the engraver David Loggan in 1675 shows the
small quadrangle (now called Mob Quad) just behind the chapel.
From *Oxonia Illustrata*, Oxford, 1675.
Inside front cover: Engraving from *The Illustrated London News*,
November 12 1864. © The Warden and Fellows of Merton
College, Oxford.

Cover design by Dot Little at the Bodleian Library
Designed and typeset by Ocky Murray in Sabon
Printed and bound by 1010 Printing International Ltd.,
on 157gsm Top Kote matt art paper

British Library Catalogue in Publishing Data
A CIP record of this publication is available from the British Library

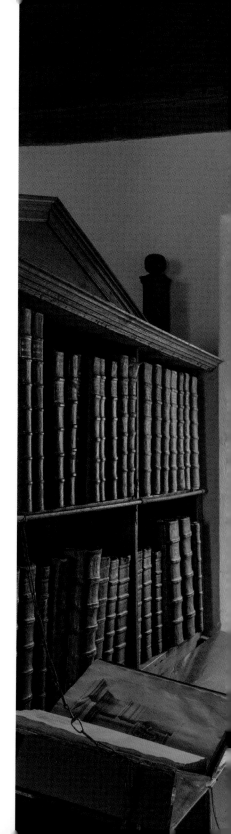

Contents

Timeline

1264
Walter de Merton issues the first statutes establishing a self-governing 'House of Scholars' managing their own endowment

1274
Merton College (warden, fellows and other staff) on site in St John's Lane (now Merton Street)

1276
Archbishop Robert Kilwardby requires fellows of Merton to leave their books to the college on their death

1284
Archbishop John Pecham requires the college to chain three essential reference books in an accessible place (origin of the chained collection at Merton)

1335–36
First surviving mention of a library room in the college's administrative records

1379
Completion of the small quadrangle (Mob Quad) by the addition of the south and west wings, housing the new library on the first floor

1385
Death of William Reed, major benefactor of the new library and donor of hundreds of manuscript books to Merton and other colleges

1476
Chaucer's *Canterbury Tales* printed for the first time by William Caxton in Westminster

1484
Warden Richard Fitzjames issues library regulations, including keys for fellows

1503
Library ceiling with painted bosses installed

1534
Act of Supremacy declares Henry VIII head of the church in England

1549
Royal Commission (under King Edward VI) to enforce Protestant religious observance in Oxford colleges

1556
Royal Commission (under Queen Mary I) to enforce Catholic religious observance requires colleges to submit a list of books in their libraries

1563
Thomas Bodley comes to Merton as probationer fellow (elected to fellowship in 1564)

1585
Henry Savile becomes warden of Merton

1588
Savile begins refurbishing of the college library

1602
Construction work on the university library, funded by Sir Thomas Bodley, advised by Henry Savile, completed

1613
Death of Thomas Bodley, buried in Merton Chapel

1622
Death of Sir Henry Savile

1623
Completion of the refurbishment of Merton library, under Warden Nathaniel Brent

1642–51
English Civil War

1643
Queen Henrietta Maria (wife of Charles I) resident at Merton

1659
Position of college librarian established at Merton by the bequest of Griffin Higgs (1589–1659)

1667
Robert Huntington (d.1701), first fellow to be appointed Higgs Librarian

1792
College resolves to remove chains from library books and to make further changes to accommodate more books in the library; library borrowing register established

1827
Undergraduates permitted to use the college library for one hour per week

1841
German sixteenth-century stained glass installed in the library

1861
In May, the college resolves to demolish Mob Quad, if necessary, to create more accommodation for undergraduates

In October, the decision of May rescinded; college agrees to keep Mob Quad and the library

1897
College library open to undergraduates three hours every weekday morning

1901
Chapel sacristy refurbished as a library reading room

1906
Open-access library and reading rooms created on the ground floor beneath the Upper Library

1929
Bequest of books from the philosopher F.H. Bradley and creation of the Bradley Library reading room on the ground floor of the Mob Quad

1941–45
Medieval manuscripts and stained glass moved from Merton to the Bodleian underground stacks for safety during the Second World War

1950s
Science library and law library rooms established in the Old Warden's Lodgings

1961
The Beerbohm Room, adjacent to the Upper Library, opened to display some of the recently acquired Beerbohm Collection

1980
Merton admits women students

1994
First professional fellow librarian and archivist (and first female librarian) appointed, Sarah Bendall

2004
Blackwell Collection donated by Julian Blackwell

2014
Merton College celebrates 750th anniversary

Introduction

No library has been in continuous use in a university for as long as the Merton College Library. The college was founded in 1264. It was from the start an independent part of Oxford University, established by England's chancellor Walter de Merton as a charity to support a community of scholars, the fellows, who were, and are, teachers of the university and who also form the governing body of the college under the leadership of a warden. Around a century later, they were joined by undergraduate students who were taught by the fellows. They lived together in a cluster of buildings on the southern edge of the city, taking their meals in a hall and worshipping in the college chapel. The college continued its corporate life through the Reformation in the sixteenth century, the Civil War in the seventeenth century, the intellectual doldrums of the eighteenth century (in Merton at least), the academic reforms of the nineteenth century and the social reforms of the twentieth century. Throughout all these changes the library remained at the centre of college life, occasionally at the centre of conflict. We know a great deal about the part it played thanks to Merton's exceptionally rich

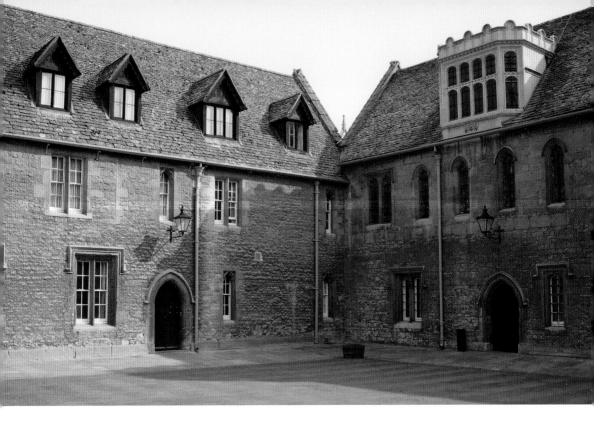

Exterior view of Merton College Library.

archive and thanks to the survival of contents and architectural settings that provide evidence of the library at different stages of its long history.

Today Merton's library is housed in two main locations: the grand Edwardian 'Old Warden's Lodgings' on the north side of Merton Street, and the historic Upper Library and Lower Library forming part of the oldest quadrangle in the college – since the eighteenth century known as 'Mob Quad'. From its earliest days the college library has been a common endeavour, although this has taken several forms. This book tells the story of the library – how it originated, how it grew, how it was housed and used, how the treasured historic building almost did not survive the nineteenth century and how it came to be shared not only by the few members of a single college but also with visitors and scholars around the world.

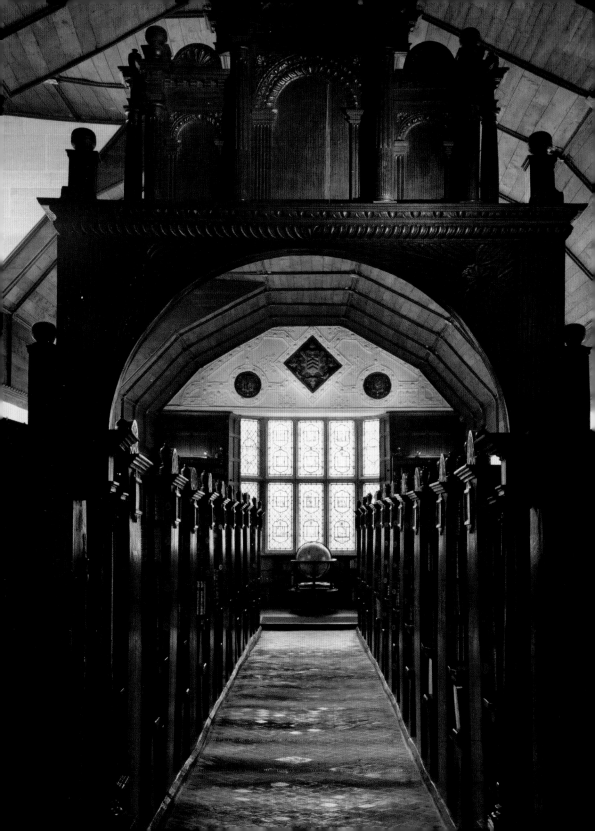

The beginnings of a library

<div style="text-align: right">1</div>

A library was not part of Walter de Merton's plan for his new college. The college statutes, drawn up in three successive versions in 1264, 1270 and 1274, do not mention a library. There is a brief reference in 1270 to books that should be provided for those whose college position required them (such as the fellow in charge of helping the younger members with their Latin grammar). But it was not long before two members of the intellectual preaching orders introduced to Merton some of the same elements of book organization in practice among the Dominicans and Franciscans.

In 1276 Archbishop Robert Kilwardby, in his role as college visitor (the external authority who was responsible for settling college disputes and ensuring that the warden and fellows followed Walter's statutes), introduced the requirement that all fellows leave their books or an equivalent sum of money to the college on their death or if they resigned their fellowship to join a religious order. Kilwardby also said that the books were to be kept in chests with three locks (in the same way that valuable documents were kept), and that books could be assigned to fellows for their use on payment of a 'security'. The

South wing of the Upper Library looking east.

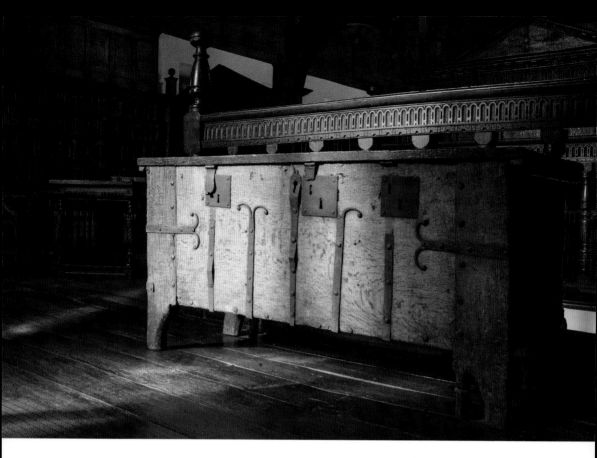

college had the option of selling bequeathed books to clear a fellow's debts or in the cases where they were not wanted by the library. A few years later in 1284, Archbishop John Pecham ordered the college to acquire three basic grammatical works and to chain them to a solid table or desk where everyone in the college could have easy access to them. This may have been the beginning of the chained library at Merton.

The arrangements for administering the collection of books that began to grow from the gifts and bequests by fellows and others were similar to those in practice in communities of religious orders in Britain and in the College of Sorbonne in Paris (only a few years older than Merton). The college needed two types of collections of books. The chapel housed the books necessary for religious services, and these were distinct from the

Chests like this very solid oak chest with three locks provided secure storage for valuable items such as books. It is now at the top of the stairs in the Upper Library, but records indicate that book chests were sometimes kept in the warden's lodgings.

books for academic study, teaching and pastoral activities such as writing sermons. The books that supported the academic life of the fellows formed a common study collection, known initially as the *libri communitatis*, or 'books of the community'.

Although the collections of books were growing, there was no librarian. Instead, the bursars (a college office that was held by fellows in turn) were responsible for the safekeeping and administration of these valuable assets, just as they kept accounts of the income from the college estates and of the expenditure on food that was eaten in the college hall. Later, in the late fourteenth and fifteenth centuries, the subwarden took over primary responsibility for the books.

Two ways of storing the academic (non-chapel) books developed from the injunctions of Archbishops Kilwardby and Pecham. Some were kept in chests while others were chained so that they were accessible but secure. This anticipates the modern distinction between loan and reference library collections. The earliest mention of loaning books from an Oxford college is recorded at University College in 1292. At Merton there are references to the loan of books to the fellows from a common collection in the 1330s. The circulating collection became the larger of the two academic book collections. These were probably the books that the fellows used most intensively. The loan collection could not be browsed in the sense with which we are familiar today. Books were costly, and the chests in which the loan books were kept were opened only periodically when members of the college gathered together for the borrowing and return of books, known as an 'election' or 'distribution'. These book elections were corporate events, presided over by the subwarden or the warden. There is little information about how this process worked in the early decades, but later it seems that fellows were given an allocation of books suitable for the point they had reached in their academic career. Often a fellow would need to leave a deposit, such as a book from his personal collection, commensurate

enim h contere corpus ipsorum hijs aut
accidit manifestum nichil tale manife-
stum ut theris. Singularia aute horum
z in quibz gignent locus ex hystoria nscebr.
[initial] Generatioe incipi-
ne quidem liber
g alium de iuis.
ctum est z ta-
ter z sigillatim de
onibz qm aute
m p sciam. ip-
sorum sunt fe-
mella z masculi
separata z has uirtutes pncipia dicuntr
ee olim z alium z plantarum. S3 h quide
ipsa in separabilia hte hz aio separata
dr de gignoe hor primo. [¶] Ad h em ex-
istentibz impsecis in femella dterminatur
femella z masculus ytriusaue z alio-
dm manifestam ee ad censu utin. hz
quide femella h aio masculus est. z
mine accipientia dm mano pus dubi-
tatur. Aumo enim hij quide in sper-
matibz ee hanc contrarietatem confessi
ut anaxagoras z alij philogorum si-
enim ex masculo spma femellam au-
tem ewluere locuti z ee h quidem mas-
culus ex dextris femellam aut ex sini-
stris z maleic qui quid masculinam
dextris sunt. femelle aio in sinistris
hij aut empedoque quid n in caliai
ueuientia matricem masculina si-
aliunt q aio in frigidam femmina.
Caliditatis aut z frigiditatis fluxi
nistruoz cam ee aut frigidiorem ab
calidiorem existentem z antiquiore
aut recentiorem. [¶] Democrius aute
abderitos in miuie quid te femellam
h aio masculus h ctiliq utriqz obti-
niut spma qa pticula uenit quia
differunt ab inuicem femella z mas-
culus hxe cui ue te empedo in nsicum

tium suspicatus est putans frigidita-
te z caliditate differe ab inuicee toti
uidetur totas ptes magnam iuter osau-
eam que putendor z maris. si n toto-
rum alium. hoc quidem histe omu pti-
culas femelle. hz a masculi z qadm in
cauiui in matre pouantur. huic quod
matricem in cali dam ilo hul matrice
z masculus hte. h aiet impossi. qt cte q-
cdm meinu utriq dicio democtus. Cr
tte n hui gignoe quam z temptans di-
cere. Si aut bu aut no bi altera io.
[¶] S3 ad huc ti sto pticularu dictie cu
caliditas z frigiditas h dr illo modo
oistibz. h io e ite dicet de gignoe mascu-
us femelle dicere. hec ein differeit ma-
infeste io modici manifeste tp opus
oduce ab illo puels de gignoe haru pti-
cularu cam tanq nectu conseca. in frigi-
dato quid ali si hac pticula matce. ea
lesto aio io si. Gode aut moo z de
hijs q ad coteli faciut pticult z ei hec
differunt qadm deta est prius [¶] Ad
huc aut sumo gemelli femella z mas-
culus simul in cate pticula matris
sixqun h hoc sussiciens ofiauium ex ana-
conuis in omibz aisicantibz z maxi-
uis zin piscibz de quibz si no osiauit
ronabilo utiq peccauit hanc cam di-
cens. Si aut uidim in quenens adis-
putare cam ee caliditate matris aut si-
giditate. Auuo n utriq sieue aut femi-
na aut masculina. Nunc aio h ui
uenui accidut dicenti qt pticulas di-
stahi cui q siv. has quidem n in mas-
culo aio et. has aut in femellam xp
z collocutionis ad inuice ocupisce ne-
cessariu z tahi distinctio ot magbudi
nem z si conuentu. h no xp frigiditate
aut caliditatem. S3 de tali quide ca
spmatis sorte utiqz erro multa dicet.
Totali ein usus est modi ese q sigill

with the value of the books he was borrowing. An inventory was taken and records were kept of the books issued to each fellow. Merton has the earliest surviving election list from the Oxford colleges. Dating from 1372, it is written on a parchment scroll and records the surname of each fellow along with a brief identifying description of the book given to them.

The chained collection was a smaller collection. In theory, books chained in a room that came to be called the library (*libraria*) were always available to fellows. These might be the most valuable copies of essential texts or copies that were used for looking up information or references in authoritative works. Because they did not get carried around college or taken to lectures, they were at much less risk of getting lost or damaged – a situation which some donors appear to have had in mind when expressing their wishes about the fate of their donated books to the college. An illuminated copy of Flavius Josephus's *Antiquities of the Jews* (MS. 317) for example, given sometime before 1339, includes a donation inscription with very explicit instructions about the storage and care of the book:

This book belongs to the House of Scholars of Merton in Oxford and to the fellows of the house, given by Master Nigel de Waver, former fellow, who gives it [*dedit*] to be chained in a common place [*loco communi*] and not removed from there for private use without the consent of the fellows present in the college at the time.

There are no descriptions or illustrations of the early Merton library, but the detailed expenditure accounts kept by the college bursars provide information about it. Certainly, by the early decades of the fourteenth century there was a room, referred to as the library where books were chained to desks for use on site. The room had glazed windows by at least 1335, when some of them had to be repaired. There were wooden lectern desks, whitewashed walls and rush matting

Some of the books that were in the loan collection may now be considered luxury books because of their decoration. This text of Aristotle's zoological writings, *On Animals*, was made in France in the last part of the thirteenth century. By 1372 at the latest it was in the circulating collection at Merton and was borrowed by Thomas Swyndon. The historiated initials and marginal images at the start of each section of the manuscript depict a variety of animals, relating to the subject of the text, as in this chapter on animals and reproduction. MS. 271, fol. 136v.

on the floor. As early as 1308 there was also a map of the world (*mappa mundi*); we know this because at that date it had to be repaired.

What kinds of books were in the medieval library in its first hundred years?

No complete catalogue of the early library survives, but the college archives fortunately preserve two relatively early lists of books which show that by the first quarter of the fourteenth century the books were divided into two general categories: 'philosophical' and 'theological'.

Catalogue of philosophical books, 1318–1334

The earliest surviving list of books in the Merton library is a catalogue or inventory of eighty-five 'philosophical books' from the first three decades of the fourteenth century. At Merton the designation 'philosophical' was used to denote the texts relevant to someone preparing to become a Master of Arts (MA) – the main professional university qualification. This list therefore includes copies of texts by Aristotle and commentaries on those works, as well as other philosophy texts and works of logic, mathematics, astronomy and grammar. The list appears to have functioned more as an inventory than as a finding-aid. Entries provide information on the monetary value assigned to the book, the contents of each volume, the donor, if one is known, and sometimes the book's condition or binding, such as whether the texts are in pamphlet form or bound in calfskin (a relatively expensive binding). Fewer than half of the entries have donors' names, an important reminder that the college purchased books when needed and did not rely entirely on donations and bequests. Two astronomical instruments (astrolabes) are included. Since no storage location for the items is given, it is possible that the books on this list were part of the loan collection and were stored in a chest.

The earliest list of Merton library books (1318–34). One of the two surviving books on this list is a copy of the *Institutiones grammaticae* (Principles of grammar) of Priscian (now MS. 309). The list shows that there were three copies of this text at the time. The value of MS. 309 is given as two shillings. Catalogue of Philosophical books: MCR 4250.

Catalogue of theology books, *c.1349–c.1360*

This inventory is organized like the earlier list, but its rows and columns are neatly ruled, and it includes the location of the books, specifying that thirty-one volumes are *in libraria* (i.e., chained in the library). Some 250 books are recorded, with the donor's name or, alternatively, an indication that a given volume was purchased by the college.

The theological books are divided into categories such as biblical history, different kinds of biblical commentaries, copies of Peter Lombard's *Sentences* (a theological compendium that was a major textbook at Oxford and Paris), commentaries on the *Sentences* and works of the Church Fathers. A number of important works were held in multiple copies. There are, for example, eight copies of Augustine on the Trinity, the most expensive of which, at forty shillings, was kept in the library room.

Features of books for scholars

By the thirteenth century, many books made for use by academics already had a number of visual features commonly found in printed books today, such as tables of contents at the beginning and running titles along of the top of each page to help the reader locate specific chapters and subsections.

Other characteristics relate to the ways in which texts were studied and used. A volume that had been used by other scholars before coming into the library was not necessarily of lower value than a newly written copy. The opposite might be the case. Medieval academic books could be the product of several layers of readers and were not necessarily 'finished' when the main text was complete. The margins were often made quite wide, to provide room for the addition of formal commentary or for annotations by the reader. Vertical rulings in the margins helped keep these marginal annotations ordered, making it easier not only for the annotators but for later readers. It is not uncommon for manuscripts to acquire

The layout of the pages shown opposite is typical of books made for university study in having plenty of marginal space ruled in columns for readers to add their notes. In this case one early reader has provided a formal running commentary or gloss, while others over the years added more sporadic annotations, profile heads and pointing hands. The volume was given to the college by John Reynham, a fellow whose name appears in college records from 1321 to 1331. MS. 309, fols 64v–65r.

annotations by several generations of readers – whether these were formal commentaries (glosses) copied from another manuscript or notes from a university lecture or the reader's own comments. The combination of text, commentary and marginal notes can be understood as in some ways recapturing the debates and formal disputes that were part of the medieval method of teaching and of developing new ideas. The manuscript pages have several 'voices'.

Aids to using books

In addition to major texts and commentaries, the library included aids to finding useful information in these texts: indexes and guides to contents. The writing of commentaries,

compendia and sermons required references to other sources and to authoritative texts. How do you find out otherwise which works of Augustine mention 'angels'? Scholars therefore compiled indexes to major works, sometimes adding an index to their own copy of a work or creating an index that could be used for any copy. Because the pagination of books copied by hand was not uniform, these indexes commonly refer to titles of works, chapters and subsections in which the desired passage can be found. Several particularly useful subject indexes soon became reference works in their own right and were copied many times.

From theory to practice

How did the use of the library work in practice? A rare bit of evidence from the late 1330s lets the fellows speak for themselves. At that time the fellows of the college would meet three times a year at a special meeting called a 'scrutiny' at which everyone could speak in turn, and obviously pretty freely, about any problems they perceived in the college community or breaches of the statutes. This type of meeting was probably inspired by the chapter meetings held regularly in cathedral and monastic communities. Records of three meetings held in July and December 1338 and March 1339 have survived in the form of notes with fellows' names and the points that they raised. Although the majority of concerns are about disagreements between certain fellows and the negative effect this was having on life in the college, there are also some remarks about the library and books. From this we learn that several fellows at this time wanted increased access to the library, more frequent distributions of books, more copies of canon (church) law texts in the library, and also that some masters were monopolizing the philosophy books, even though they were not currently studying those subjects (presumably because they had already completed their MA).

[opposite] In this copy of homilies on the Gospel of Matthew by John Chrysostom, an early fifteenth-century owner added a subject index with references to the number of the relevant sermon. The alternation of red and blue initials helps the reader to distinguish separate entries in these narrow lines of text. MS. 38, fol. 18r.

[following spread] Roger Martival (d.1330) had been chancellor of the University of Oxford before becoming bishop of Salisbury in 1315. He is one of the wealthy non-Mertonian donors to the college library. Among his gifts was a four-volume set of the *Mirror of History* by Vincent of Beauvais. These attractive books were copied and illuminated in Paris at the beginning of the fourteenth century. MS. 123, fol. 5r, and MS. 124, fol. 3v.

De causa suscepti operis et eius materia.

[Heavily abbreviated Gothic Latin text in two columns, largely illegible in reproduction.]

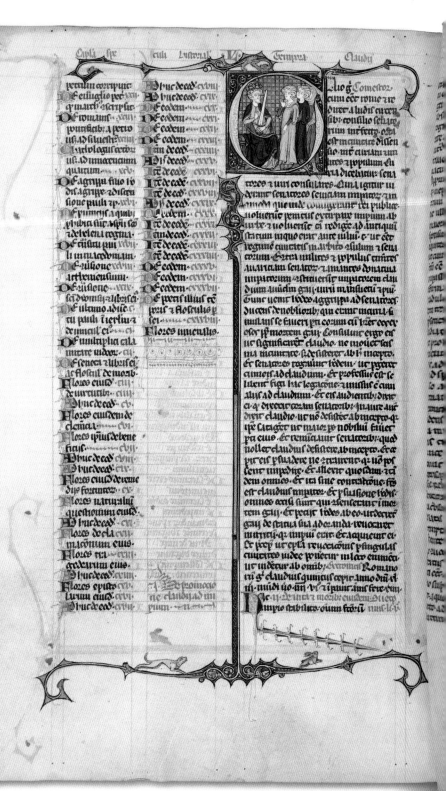

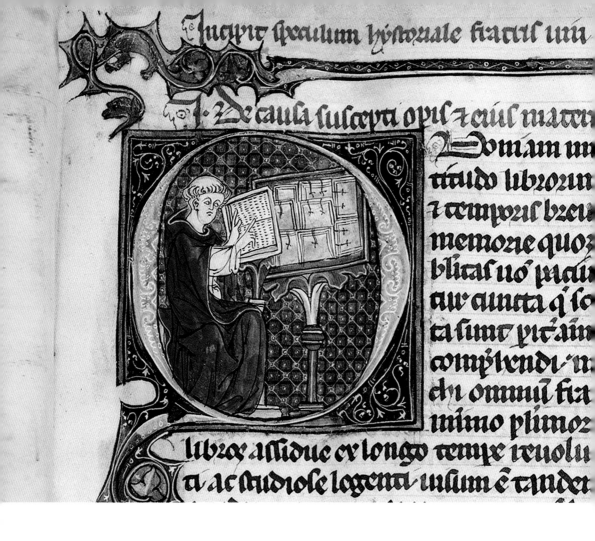

Incipit speculum historiale fratris un̄

De causa suscepta opis ⁊ eius mater

Gifts and bequests as commemoration

Fellows were required to donate or to bequeath their books, but donations also came from those external to the community, and a gift to the library was a pious act in support of the charitable intentions of the college, similar to a gift of vestments for the chapel. The names of sixty donors to the library survive in the Merton records before 1372, even though only some of the books they gave have survived. The donation inscriptions in the books themselves reinforce the memorial role of the physical books, and this is the case with other

The author, Vincent of Beauvais, is shown seated at his desk with many books to hand at the opening of *The Mirror of History*. Detail from MS. 123, fol. 5r.

institutional libraries as well. The wording of such inscriptions is very similar to those found in manuscripts from other English colleges and in the early books of the Sorbonne library. The donor and his association with the college are specified, but the inscriptions may also ask for the reader's prayers for the donor and sometimes for his parents or named friends. Not all Mertonians were named in the prayers for benefactors read out in the chapel, but everyone who opened a bequeathed book would see the inscription and, through their prayers, could do a service to the original donor. It is possible that the recording of donors' names in the fourteenth-century booklists of the Merton library may have had a memorial as well as an identifying function. It has been suggested that a donor's express wish that their books be kept in the chained library may have been to ensure that their memorial survived longer than it would have if their books were subject to the risk of loss in the circulating collection.

William Reed and Simon Bredon: friendship, collaboration and the development of the Merton library

By the time that the college was a hundred years old, Walter de Merton's plan for a community of scholars living, eating and worshipping together and supporting each other in their studies had proved successful. Walter intended the fellows of Merton to concentrate on theological studies, but other subjects flourished at Merton as well. The close community may have been a crucial factor in fostering scientific, mathematical or astronomical developments in the first half of the fourteenth century, a period of astonishing creativity when Merton achieved an international reputation, giving rise to the term 'Merton calculators' to refer to their studies in mathematics and proto-physics (cutting-edge logic was also strong). The energy and the spirit of shared intellectual enterprise of this generation of fellows also influenced the next generation, those who came to the college from around the 1330s to the 1340s.

Two members of this later group of scholars (active in fields of astronomy and astronomical observation in the second third of the fourteenth century), Simon Bredon and William Reed, who were friends and collaborators, were to have a major influence on the library at Merton. Bredon, who had become a fellow of Merton by 1330, was the older of the two. He was unusual in having studied both theology and medicine, and he practised as a physician while holding ecclesiastical offices after leaving Merton. Reed was a fellow at Merton by 1344, studying theology and pursuing a successful career in the church (serving as bishop of Chichester 1369–1385). Both men had an interest in astronomy, collecting relevant books and astronomical instruments, and compiling their own astronomical tables. Several surviving manuscripts, originally at Merton and now in the Bodleian Library, bear witness to the sharing of manuscripts between Bredon and Reed and other fellows of Merton. Marginal annotations evoke an intellectual collaboration in which books and working notes were passed from one to another and to others in their circle.

Both Bredon and Reed made legacies of books and astronomical instruments in their wills – somewhat surprisingly to multiple colleges, though the greater number to Merton. William Reed (d.1385) was a major benefactor of Merton. He acquired a large private library in his lifetime – at least 528 books were owned by him – possibly the largest private collection in England at the time. Reed made significant gifts of books during his lifetime, providing good evidence that he may have acquired some of them in order to place them with colleges of the university. Unlike fellows who supported one or two institutions with which they were connected, Reed acted on a grander scale. Overall he gave and/or bequeathed books to Merton, Exeter, Balliol, Queen's and University College, and to the recently established New College. As there was no functioning university library in his

William Reed's donations to Merton included scientific and medical texts, such as this illustrated Italian surgical treatise. The miniature shows treatment of a back problem with traction. Bodleian Library MS. e Mus. 19, fol. 162r.

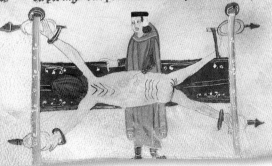

oe signa nobit 7 b. fixū ·yx· oe ipliaate fiaut oe nobit angl· oe fixā aduf· oe coi
succedūs· oi obediencʒ opposito eū obedie obedit oppositū· Si ꝗ oidamᵉ oppo̅ᵗᵒ aug
vadat ꝗendit apparit· Aubʒ ναssoulū͂ oppositēₜ mattelutin· Aubʒ fōᵐ oppsītᵉᵗenia
οⁱₛ ipliaate ⁷ Ab anglᵗ fapiⁱ oⁱₛ opd· ab angli̅ ad anglⁱₙ· oᵉ Afpeᵈ loeⁱⁱ ⁱ ꝛaꝺꝗᵒ
ⁱ ꝯ̅ꝗⁱ ꝼoꝗosiᵗⁱ ꝗⁱuⁱᵈ · ꝺetul plᵗʒ i̅uⁱs legⁿ̅ ī̅ ⁊ī̅ᵉ· ⁊ī̅ ꝼꝼ· Cubʒ q̅anꝯⱽ oppⁱsⁱᵗᵉ
ꝯ̅ꝺ̅ⁱꝓ̅ᵉ ⁊ʃuⁱᵈⁱ̅ⁱⁿᵉ· oppᵃⁱ̅ʃ ſuⁱᵈⁱᵗ̅ⁱⁿᵉ· ⁊ anglⁱ̅ oppaⁱᵉ anglⁱ̅· Cubʒ nobit oppᵃⁱᵗᵒ nobit· Cubʒ ꝼꝼⁱⁿ
oppᵃⁱᵗ ꝼiⁱⁿⁱ· ⷢ Cubⁱᵗ· cul oppaⁱᵉ oe

This manuscript from William Reed brings together within two covers several astronomical texts that were originally separate booklets. Astronomical and astrological diagrams were also included. Some of the diagram inscriptions were later carelessly cut away by a bookbinder in the seventeenth century. MS. 259, fol. 40v.

time, Reed's gifts can be seen as anticipating Thomas Bodley's benefactions 200 years later.

William Reed transformed the Merton library. By the 1370s the Merton book collections may have comprised around 330 volumes (the lists do not provide enough information to determine accurately how many of these were in circulation and how many chained in the *libraria*). In total Reed gave Merton some 250 books, and to these were added astronomical instruments (perhaps ten), including the large fourteenth-century Oxford astrolabe-equatorium still in the library. These donations necessitated a bigger library room, and Reed provided some of the cash to fund it. His gift of £200 ensured that a new library could be built. He had a number of meetings with the bursar and others, so it is plausible that the new library was in part Reed's plan.

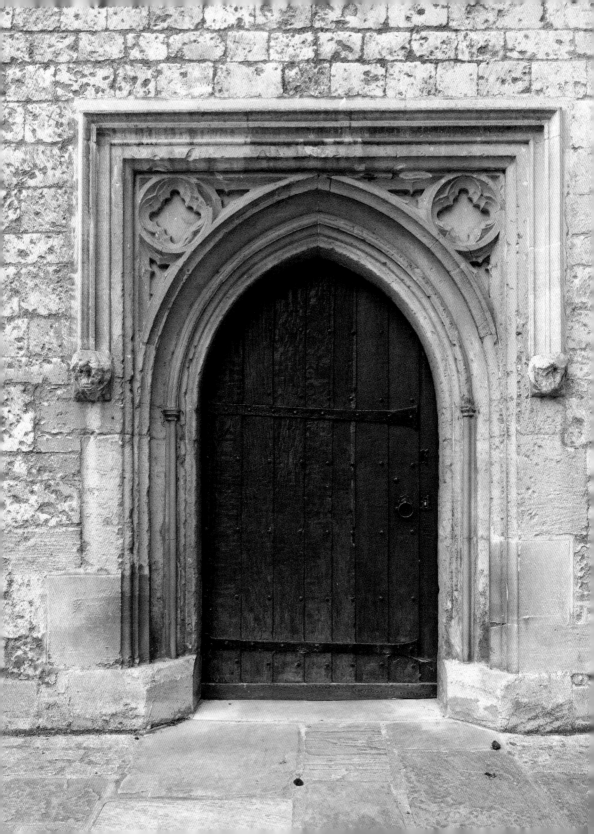

Fourteenth and fifteenth centuries

<div style="text-align:right">2</div>

The new library

I n 1373 the bursar of Merton, John Bloxham, and the master mason William Humberville travelled to London at college expense to have a look at the library of the Dominicans, which, along with the Dominican library at Oxford, was one of the largest academic libraries at the time. They also visited Sherborne, Winchester and Salisbury, probably to see the libraries of the cathedrals. Humberville had worked at Windsor Castle, so it was evident that the college wanted an experienced and skilled person in charge of the new library building. By 1378 the cumulative amount expended on this project had come to between £500 and £600 – a sum greater than the college's annual income around that time. When it was finished, the new Merton library was the largest library in England aside from those of religious orders.

Construction took place over a period of five to six years, with most of the structural work completed by 1379. At least some of the stone came from the quarry at Wheatley, about 5 miles from Oxford. A strong outer door, still in use, was acquired from the local Carmelite friary. Together with the adjacent buildings from the first part of the fourteenth

The library door in the south-west corner of Mob Quad may be older than the library. The college accounts in the 1370s mention acquiring a door from the Carmelite friary in Oxford.

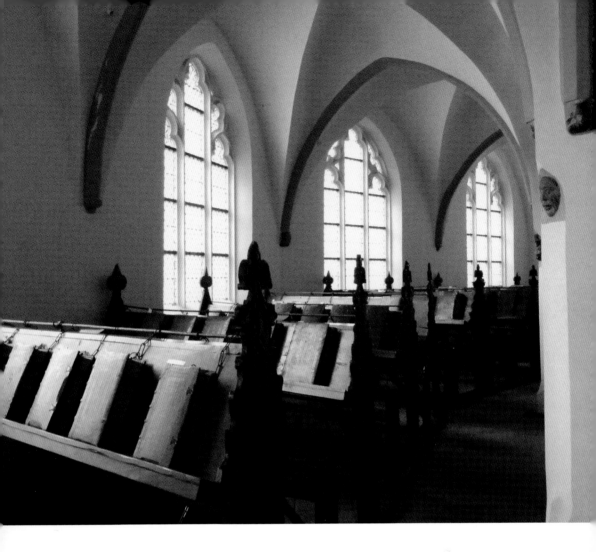

century, the new building formed a quadrangle, known until the eighteenth century as the '"Little" Quadrangle'. The corner of this quadrangle nearest the hall and the sacristy was anchored by the stone-built muniment tower (or treasury), erected in the late thirteenth century to keep valuables and the even more precious charters and administrative documents relating to the college's property (on which the college's very existence depended). On the opposite side of the newly formed quadrangle, the intersection of the two wings of

The surviving double-sided lectern desks in the church of St Walburga in Zutphen in the Netherlands date from the mid-sixteenth century but provide an idea of the appearance of the double-sided Merton desks some 200 years earlier.

The main imagery in the medieval library windows is found in the colourful roundels set into grisaille glass. The visual references to St John the Baptist through the Agnus Dei (Lamb of God) link the library symbolically to the nearby college chapel and evoke the college community as a whole. Perhaps the reference to St John was also a subtle way of acknowledging John Bloxham, who had participated in planning the library and was elected warden in 1375.

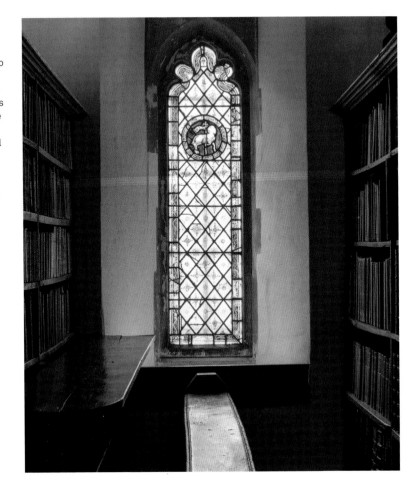

the library provided a second anchor, forming an axis of corporate treasure, both literal and intellectual. Residential rooms for fellows occupied connecting wings and the ground floor of the library.

Each of the two library wings had a series of single windows on either side running the length of the room, and the larger space at the junction of the two wings was lit by much taller double windows. Furnishing of the library continued for more than a decade. The west wing was furnished first, and then

The small painted lion masks on some of the quarries in the medieval windows were echoes of the lions in the royal arms of England and were popular in decorative imagery in the late fourteenth and early fifteenth centuries.

the south. In each, a central aisle was flanked by double-sided wooden lectern desks projecting from the walls between the windows, with benches between the desks providing seating for either side. These lecterns do not survive at Merton, but they were probably similar to the later lectern desks that can still be seen at Lincoln Cathedral or the library at the church of St Walburga in Zutphen in the Netherlands. The grondsells, or beams running along the floor into which the seats and lecterns were set, are still in place.

The progress of work on the library can be followed in the account rolls in the archives. Forty-eight chains were purchased in 1387, for instance, and in 1394 Walter Rammesbury, a

fellow, gave £10 for new lectern desks in the south wing. When all the desks were installed, the library could house about 500 books stored flat on the lecterns and chained so that they could not be removed. There would have been space for approximately fifty readers.

The 'philosophical' or arts books would have been stored in one area and the theological books in another, an arrangement that was to continue into the early modern period. The law books were also kept together, but other than these very rough divisions there was probably no further subdivision into classifications. Each book had its own fixed place on a given desk, and whitewashed panels on the aisle ends of the lecterns provided lists of the books kept on each desk.

The many windows would have been protected with shutters. Some of the original late fourteenth-century stained glass survives in the east windows of the west wing. The design of the stained glass in these windows maximizes light but creates a decorative effect with the delicate black and yellow patterns of the borders and the painting in each of the smaller diamond panes (or 'quarries'). Many of the central roundels contain images of the Agnus Dei (Lamb of God), the attribute of the patron saint of the college chapel, John the Baptist.

What else was kept in the new library?
Books were not the only contents of the library. A world map has been mentioned, and there was also a map of England, which may have been useful for planning journeys to the college's estates, some of which were as far away as Northumbria. In the days before university laboratories, astronomical instruments, such as those bequeathed to the college by William Reed and Simon Bredon, were also part of the library collections. They were working tools that could be loaned to fellows and that sometimes appear listed in the election lists. The five surviving instruments are displayed today, but it is estimated that the college once had more than

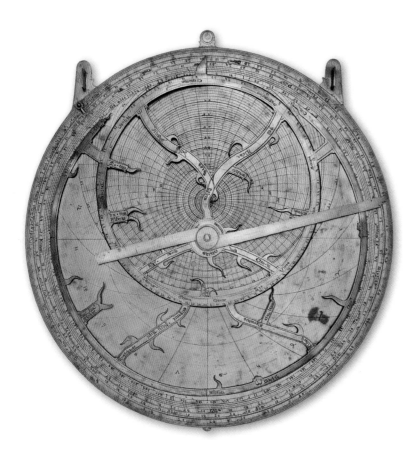

twenty astronomical instruments in the medieval library. It is doubtful that the heavy book chests, like the one now at the top of the stairs, were always kept in the library room, since, at least in the fifteenth century, records of the distribution of circulating books indicate that these events were held in the hall or in the warden's lodgings.

The warden's collection

By the fifteenth century a smaller collection of books was kept in the warden's lodgings and administered by him. These seem to have been college-owned books, drawn from the library collections, for the warden's use. Inventories were taken when the wardenship changed hands. The warden from time to time

Astrolabes were instruments for studying the motion of the sun and stars. They were also practical tools for calculating time accurately. Measuring fourteen inches across, the astrolabe above was made about 1350 to be used at the latitude of Oxford. Each of the flame-like pointers represents a major star. On the reverse side is the oldest surviving example in metal of an equatorium, a complex instrument for determining the positions of planets.

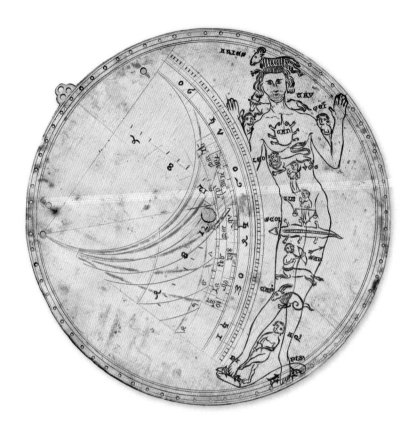

In contrast to the large astrolabe, the brass disc above can be held in the palm of your hand. Half of the disc is filled with the inscribed angles of a quadrant for determining the altitude of celestial bodies. The figure of a man incised in the remaining space indicates which signs of the zodiac influence particular parts of the human body. This would be a useful aid for a physician when deciding on the timing of treatments such as bloodletting.

lent some of these books to fellows, so they formed a kind of third library collection.

Books as portable assets

Books were essential and valuable for study, but they were seen as common assets for the fellows in a much more literal sense as well. Archbishop Kilwardby's early instructions had required that fellows borrowing volumes from the college loan collection were to leave a security deposit, called a 'caution', usually in the form of another book. In later years it appears that the deposit was not always made in advance, but could be claimed by the college as a fine if the books were not returned.

Books could be 'pledged' to obtain a kind of short-term loan via the university. Originally the named 'chests' in the university were just that: large chests like the book chests in colleges, used for the safekeeping of items – usually books – deposited to secure a loan to eligible members of the university community. When a book was pledged and redeemed, the value set on the book by the university official was sometimes written in the book itself, along with the names of those making the pledge. Books not redeemed by their owners/pledgers could be sold to others. From notes in the back of several Merton manuscripts it is clear that these volumes had been through the pledging system, sometimes more than once. What can be surprising is that there is evidence that some of these volumes were already in the Merton collection when they were pledged. A fellow might receive a book as part of his allocation of loans at a college election and then subsequently pledge the book in one of the university chests. It would appear that these were not unusual instances of fellows misusing college property but that, as long as the books were later redeemed and returned to the college, fellows were allowed to realize their value during the term of loan. What was troublesome to the college was the failure to return the books. In several instance the college had to pay to redeem its own books. In one extreme example, a book pledged by a fellow sometime between 1446 and 1452, was finally redeemed by the college only in 1494, some 40 years later!

Caring for the library

Throughout the late fourteenth and the fifteenth centuries, fellows continued the practice of donating and bequeathing sizeable numbers of books to the library. But the library books also needed repair and care, and there are fifteenth-century inscriptions in manuscripts recording that the rebinding and repair of a given book was paid for by a fellow. The largest of these gifts was a bequest by John Martock in 1503–4, which

The majority of books in the medieval Merton library were intended for serious study and were not heavily decorated. This copy of works by the philosopher Albertus Magnus was bequeathed to the college by the fellow John Reynham in 1376 (the new library was under construction at the time). The text was written on the Continent in the thirteenth century in a tiny and heavily abbreviated script, intended for specialists. It was valued enough to be rebound at the expense of the fellow Richard Scarborough in 1453. MS. 283, fol. 112r.

covered the costs of rebinding 104 volumes in brown calfskin
– decorative and durable (two binders were employed for 121
and 13 days respectively). The timing of this large-scale project
suggests that the installation of the fine new library ceiling may
have inspired a general tidying-up (see below).

There was no formal position of college librarian until
the seventeenth century, so the administration of the books
and the library room was shared between several college
officers –primarily the termly bursar, who was in charge of
accounting, and the subwarden, who was also responsible
for recording the acquisition of books for the chapel. Job
descriptions in the modern sense do not exist, so information
comes mostly from the various series of accounts and, from
the last quarter of the fifteenth century, from the college
register (the record of acts and major corporate events
begun by Warden Richard Fitzjames in 1483). By the later
Middle Ages the subwarden had the room at the west end
of the library that is now the Beerbohm Room, which is
conveniently located between the library and the chapel. On
a practical note, the library room needed to be cleaned, and it
seemed this was initially a job handled by the chaplains and
later by college servants.

Warden Richard Fitzjames

Newly elected wardens often use their first year or two in office
to make changes. This was certainly true of Warden Richard
Fitzjames (warden 1483–1507; d.1522), who not only drew up
regulations for the use of the college library but also oversaw a
major library building project during his term, finally making a
significant presentation of books to the college.

From November 1484, bachelor fellows (those who were
studying for but had not yet achieved the status of 'master')
were given the privilege of using the chained library, and
all fellows were issued with a library key. At this time there
were twenty fellows and ten bachelor fellows. A procedure

for keeping track of the keys was included in the new library regulations written into the college register at that time.

The 1484 Library Regulations were:

1. Do no damage to any book, either by handling it roughly or by tearing out quaternos [sections of the book]; handle them carefully and keep them from harm.

2. Do not remove any book that has been chained in the library for the use of all the fellows; and, if you know of books so removed, you should tell the warden as soon as you can.

3. If you bring visitors [*extraneum*] into the library you should take care that they do not cause the theft of books or parts of books.

4. If you lose your key and cannot find it within 24 hours you must tell the warden or subwarden.

5. If you leave Oxford [leave the university] for six days or more, you should hand over your key to one of the fellows until you return, if you do indeed return.

The regulations relate to the use of the chained library, and it is interesting that they seem to assume that non-Mertonians could be brought into the library by fellows to use the books. This must have been happening, as a few months prior to the formal regulations, the college register admonished all bachelor fellows to stay with their guests in the library, sitting at the same desk with them if necessary to see that the books come to no harm.

The borrowing or distribution of circulating books continued, but did not always run smoothly. There are six surviving election lists from the period 1408–1519, but it is

in the college register that one finds details about specific problem cases. In December 1493, for example, two fellows (Adams and Ireland) were jointly responsible for a volume of a commentary on Aristotle's *Physics*, which they had lost. They were warned that if they were unable to return the book by the next scrutiny, they would either have to turn in another book of the same value or pay a fine of one mark (about the cost of a cow, or about £450 today), and they were to be deprived of their meals if they didn't. The deadline came, and they still didn't have the book, so they paid the fine. In fact, the book turned up almost nine years later, and they were able to get a refund of the fine from the bursar. Adams seems to have been a repeat offender; 14 years later and now a doctor of theology, Adams reported that he had lost twenty books issued to him. Such a large number of 'lost' books suggests that Adams had perhaps pledged them and not redeemed them in time for the

The designs of the colourful bosses on the ceiling are heraldic references to King Henry VII (the red and white Tudor rose), and to Warden Fitzjames (the silver dolphins). Legacies left by two former fellows (Thomas Lee and Maurice Berthram) were used to pay for the ceiling, and a further donation from Thomas Harper was used to pay for the painting of the bosses.

Several of the books presented to the college by Richard Fitzjames just after he had been appointed bishop of London still retain colourful labels with his new coat of arms, the name of the author and short title of the book, Fitzjames's name and the year. 'Jerome on the Psalms, Given by Richard Fitzjames, recently Bishop of London, Anno Domini 1517.' MS. 24, back cover.

distribution. It is easy to understand why the practice of loan books died out in the early sixteenth century.

Decorated ceiling

One of the most striking features of the library, the great oak ceiling, was installed during Fitzjames's time. It was constructed in 1502–3, with significant funding coming from benefactions from three fellows. Warden Fitzjames's own heraldic device – the silver dolphin – appears in some

TERTULLIA
NUS IN IO
BRO QUEM
CONTRA IU
DAEOS SCRIP
SIT ADFIRMAT
NŪM XLI AÑ
AUGUSTI NA
TŪ ET NŪ
TIBERII ESSE
PAS SUM

xl i — Herodes ad ea quae supra crudeliter gesserat etiam hoc — XXXI
addidit uirum sororis suae salomae interficit. & cū eā
alii tradidisset uxorē etiam hunc necat. scribas quoq;
& interpretes diuinae legis similesscelere occidit.

xl ii — XXXII

IHS XPS FILI — US DI IN BETH
LLEM IUDEAE — NASCIT COLLI
GUNTUR OMNES — AB ABRAHAMUS
QUE AD NATI — QITATE XPI
ANNI — LI XV.

xl iii — Quirinus ex consilio senatus iudaeam missus census hom — XXXIII
CXCV OLYMPIAS nū possessionum q; describit.

xl iiii — C caesar amicitiam cum parthis facit. — XXXIIII
Sextus pythagoricus philosophus nascitur.
Augustus tiberium & agrippam in filios adoptat.
Iudas galileus ad rebellandum iudaeos cohortatur.

xl v — Herodes cum xpi natiuitatem magorum indicio cogno — XXXV
uisset uniuersos bethleem paruulos iussit interfici.
Herodes morbo inter cutis & scatentibus toto corpore
uermibus miserabiliter sed digne moritur.

xl vi — Asinius pollio orator & consularis qui de dalmatis — XXXVI
triumpharat LXXX aetatis suae anno in uilla tusculana

II XX xl vii — In herodis locum filius eius archelaus ab au [moritur — XXXVII
CXCVI OLYMPIAS gusto substituitur. Et tetharchae fiunt quattuor

·

fratres eius herodes antipater lysias & philippus ·

Famis romae ita ingens facta ut v· modii uenderen | IUDAEORIIDUX ·

tur denariis xx vii· semis ∫ clarus habetur | ARCHELAUS AN·VIIII·

IIII Philistion mimographus natione magnes asianus romae | h

IIIII Tiberius caesar dalmatas sarmatasq; in romana redigit potestate | II

Athenodorus thar sensis stoicus philos phus ꝯ ꝯ ꝉ IIII | IIII

flaccus grammaticus insignes habentur ·

Athenienses resnouas contra romanos molientes oppri | IIII

MPIAS muntur auctoribus seditionibus oc cisis

Messala cor uinus orator ante biennium quam morere | V

tur · ita memoriam ac sensum amisit ut uix pauca

uerba coniungeret & adextremum ulcere sibi circa

sacram spinam nato in edia se confecit anno aetatis lxxii·

Augustus cum tiberio filio suo censum romae agitans in

uenit hominum nonagies ter centena & lxx milia

| VI
| VII

Sotio philosophus alexandrinus praeceptor senicae | VIII

clarus habetur

MPIAS

Archelaus nono anno regni sui in uiennam urbem | VIIII

galliae religatur | IUDAEORUM

Defectio solis facta · & augustus lxxvi · aetatis suae | PRINCIPATUM

anno atellae in campania moritur sepeliturq; romae in | OBTINET HERO

campo mar tio · | DES TETRAR

ANORUM·III· REGNAUIT·TIBERIUS· AN·XXIII · | CHA·AN·XXVIII·

Irca diſtinctõne primã
tercii libri quentur pmo
vtrum ſit poſſibile natu
ram humanam pſona
liter vniri verbo diuino:
Qr non · pmo quia
ACTUS pimus et infinitus non eſt alteri cõ
poſibil' ſic nec in ſe eſt compoſitus qz eius infinitate et actualitate. S; verbũ
diuinũ eſt actus pur' et infinit' gº non é alti eponibl's ſ; nã humana nõ põt
vniri verbo n' per compõne: au eo gº tc Confir· non eſt poſs' vno aliqu'
cũ alio n' ſit i' addicõ alicuius ad albũ q nõ é pl's addicõ alicuius aii alio nſi
ſit i' aliqd qd prius nõ fuit ſ; infinito nich põt addi· Sic vmblia ſunt
pcedco ſ; nulla eſt gratio ſunt ad infinitũ gº nõ ſt vmblia quae tc Cº
ſic· cõtraii non ſunt vmblia eidin vt pz ex v· metª ſ; vnio eſt diſtatii diue
diuerſitas eoꝛ que nullat entibz participãt cũs ſunt cõtra· Cæii g· et mei
tũ multoꝛoꝝ non põt vniri in eodm· Cº ſic· incarnaꝰ eſt agere gº incar
nari eſt pati· S; verbũ non põt pati gº nec incarnari· iſte ſt roones oines·
Cº gº ar per alias roões ſpāles que maiores difficultates importãt· Et
hoc ſic pimo ex parte iſte aſſumpte· qz eodm nã humil' eſt actu exiſt et p gº et ipo
qz ſit nã humana actu exiſt et nõ p perſonali' illoꝰ nã· Qui pz nam ſi eod exiſt
ad albũ et colorari· ergo põt eſt qr ſit colorari et nõ ſit albũ· qz ſi coloratũ gº
hꝫt illud quo eſt colorari et illoꝰ idem eſt quo eſt albũ· g· hꝫt illud quo eſt
albũ et p vuo é albũ Ali9 oñdit· mlt· Pº ſic· qr exiſta actualis eſt nã
humane p ſe· S; exiſta in nã totã· vt ſuffice ad plurate· gº ſi nã hũma hꝫ põt
exiſtam· hꝫt eo piui plutatem· i qz eodm eſt p et exiſt· plta gº nã argun
vltima ſic· qz impoſſible exiſt in humana vniri verbo ii hꝫt exiſtm pptiam
vñ qz qz ſit actualis exiſt exiſta piia· qz ſi nõ ſit exiſt tunc nihil i eſt vmbl
S; non eſt vmbl'· exiſta merentii· qz verbũ diuin mihi eſt forma· gº ſi nã humã
vniaꝰ verbo hꝫt entm ſ p plutate qd eſt impoſ Sºidem vcio ſic ſi nõ
eodm é nã humana exiſt et perſonari· g plutas adderet ſũ nã hũm S; nõ
addit n' rñpoii ad eãm efficiente· que efficiat iſtaꝝ vnoꝰ· S; dñm eſt in zº qr
relacio caluue ad dñi in vôe oé efficientis· eſt eadem res cũ ſuo fundaₘ gº tc
Cº oñdit' idem ſic· ſie nã ad ſingularitates ſie ſingularitas ad perſonā
litatem· S; eadm realitate nõ eſt natura et ā nã ſingulaꝰ· Sie eadm realitaꝰ
ad eſt lapis huius inā lapidis et hic lapis qr alt' poſſet lapis ſ; manere
ſub nã lapidis et hre aliam ſingulaꝰitate· gº eadem ſinguľ eſt ad natura
et talis natura pſonata· Cºprimaꝰ argꝰ et hoc ex parte pſone ad quã
debet fieri vnio· In his que ſt reale· idem nõ põt vniri cũ teꝛo reale ſhuius
et non aliud· v· n· eſt ſola dñi vois nõ ſie fiat ipm cõ tle ſm qr teꝛminat
am realem vnonẽ· S; p et cõ ſunt idem real· et dñt ſola racone· Ali
eni p non eer ſimplex· g' uo põt ee vnio iſte humane n' vniat teꝛone S;
eñs eſt ſin gº tc· Cº ſic ſuppoſiti teꝛminat dependente nã ſi vnite· S; p·
diuina impecciꝰ eius diſtin' ab alia eſt relatiuẽ et diſting' re relatiõ gº ſi nã
humana vniretꝰ verbo diuino· verbũ diuin relõe formaꝰ teꝛminaret illaꝰ

of the decorative bosses (the wood and metal images at the intersection of the wooden ribs of the ceiling) alongside the royal coat of arms, the red and white Tudor rose, and the earliest surviving example of the use of the college coat of arms. The imagery emphasizes the college's corporate ties with the royal family and Fitzjames's role in this major addition to the building.

Manuscript and print

Printed books became available in the second half of the fifteenth century, but the Merton library continued to be a library of mostly manuscript books into the early decades of the sixteenth century. When Richard Fitzjames donated books to the college in 1517, they were handwritten and hand-decorated in the traditional way. Some of them were older volumes, but others were commissioned by Fitzjames with costly decoration, including his own coat of arms and, in one case, a small image of Fitzjames himself in the border decoration. The majority of these books are works of the early Church Fathers rather than medieval commentaries or more recent works. They are imposingly large, and some still retain their original bindings and soft leather coverings with book labels on the backboards. These rare bindings may have survived because they were treated with special care or possibly because they were not much used after they came to the college.

Throughout the fourteenth and fifteenth centuries, the library was a room for study and for the safekeeping of valuable books, but it was also a focal point of the college's self-esteem. The layers of visual decoration emphasize corporate identity and links to royal patrons and the college's saintly patron. Not only did many of the books come from individual fellows, but the fabric and furnishings, as well as the refurbishment and rebinding of books, were all supported by the fellows. It was a work by and for the college community.

Sixteenth century 3

A reimagined library for a new era

The appearance of the Upper Library today is the result of the changes and refurbishments that took place in the second half of the sixteenth century. These changes affected the function of the library, what kind of books were acquired, how they were acquired and how they were stored. In all of this, the religious Reformation may have been a catalyst, but it was not the only cause.

The Reformation and the Royal Commissions

England had four major religious upheavals in the mid-sixteenth century. First, the break with Rome and the establishment of a Protestant Church of England under Henry VIII (1535) with further reforms under Edward VI, followed by a return to Catholicism under Mary I, and finally the victory of Protestantism under Elizabeth I. From the point of view of an Oxford college the changes were not as immediate or as catastrophic as they famously were for monastic communities and their libraries. The first major intervention was a Royal Commission that visited the university in 1549 to enforce Protestant religious observance in the chapels and to bring

View of the west wing.

about teaching reform in the university. As a result of this, all the books kept in the chapel for use in religious services had to be discarded and replaced with approved editions. Changes to the liturgy meant that the many silver objects used for celebrating mass and for devotion also had to go. The reform of university teaching brought about change in the college library, as all colleges were required to update their libraries with more recent books for teaching across all subjects, and, as far as we can tell, Merton had done very little to modernize its collections up to this point.

Liturgical change and library change were directly linked at Merton in one very practical sense in 1549 because the funds gained from selling chalices, patens and other liturgical objects were spent with three Oxford booksellers. A summary account by the fellow responsible for this money tells us that the college

[above] A book still chained in the Upper Library shows how books would have been consulted following the refurbishments of the late sixteenth century. Antoine Desgodetz, *Les édifices antiques de Rome* (The ancient buildings of Rome) (Paris, 1682).

[opposite] A variety of subjects were included in the 1556 library inventory, such as this illustrated work on geometry and perspective by the German artist Albrecht Dürer, *Institutiones geometricae* (Principles of geometry) (Paris, 1532), p. 61.

Vnc figuraru aliquot angularium in pauimentis docebo difpofitio-
nem , & quanquam in præcedenti de triangulis inter circulos fuerit
pertractatum, tamen in fequetibus eos extra circunferentias defigna-
bo,& alio modo inter fe coniungam,nempe hoc,Ego applico fex tri
angulos fuis conis cuidam centro a,deinde necto ad latera exteriora,fingulis fex
triangulis adhuc talem trigonum,quibus interpono rurfus alios duos,& fic de-
inceps producendo triangulorum latera,& erunt noui trianguli.
Aliter poffunt adhuc trianguli inter fe difponi,ita quòd nullum fpatium inter
eos relinquatur, quu fcilicet angulus vnius trianguli medio applicatur lateri al-
terius trianguli. Quando fex trigoni fuis angulis coniunguntur, tunc efficiunt
hexagonum,cui poffumus addere,fi lubet,adhuc alios triangulos.

F

sold £71 worth of silver (a sum equivalent to at least £30,000 today) to buy books, minus the cost of hiring a horse to take the silver to London. Although there is no surviving list of these books, one can gain a fairly good picture of what they were thanks to the demands of the second Royal Commission under the Catholic authorities of Mary I less than ten years later in 1556. The Marian commissioners required each college to produce for their inspection a list of the contents of their libraries, and Merton's 1556 list is one of only two such documents to survive from Oxford.

Printed books

Merton appears not to have acquired more than a handful of printed books in the first half of the sixteenth century, perhaps because of the large number of manuscript books that were still useful for theological studies and because the lectern desks in the Upper Library were already full. Judging by later bequests, some of the younger fellows were buying significant numbers of important printed books for themselves. Whatever the reason for Merton's temporary inactivity where the library was concerned, the 1549 commission prompted a rapid change.

The snapshot of the library offered by the 1556 list shows a collection of both manuscript and printed books. The list does not provide the detail one would expect from a modern catalogue, but there are 457 titles, of which 147 were printed books mostly produced very recently, in the 1530s and 1540s; 208 manuscript books; and 102 entries that are too vague to be identified as manuscript or print. The printed books reveal that the college was making a concerted effort to update holdings in a variety of subject areas, especially in theology, science and medicine. Almost all the items in the list are still in the library today, some of them now considered significant treasures, such as the six-volume 1517 Polyglot Bible, the first item on the list. If the order of the list gives an indication of the placement of the books in the library, it would appear that the printed books

Conrad Gesner's multivolume comprehensive *Historia animalium* (Frankfurt, 1558) was a desirable addition to any learned library in the sixteenth century. Numerous woodcut images depict living creatures of all sorts, including some known only from myth or travellers' accounts, such as these colourful whales or cetaceans (pp. 246–7).

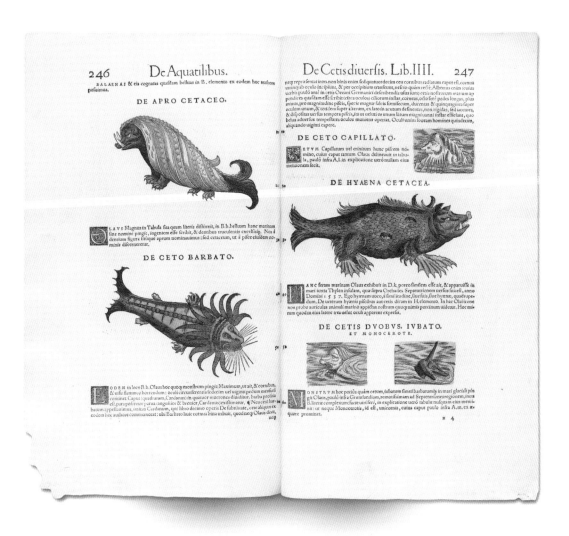

and manuscripts in the broad subject areas were kept separately on the desks, and that theology was at that time stored in the west wing, with arts subjects in the south wing.

What happened to the medieval manuscript books that must have been displaced by the newly purchased printed books? The seventeenth-century antiquarian Anthony Wood recorded in a vivid account handed down orally within the college: 'in the raign of King Edward VI there was a cart load of MSS

[manuscripts] carried out of Merton College library when religion was reformed' (*The Life and Times of Anthony Wood*, vol. 1, p. 424). This description has been frequently repeated and conjures up an image of a venerable library despoiled of precious medieval manuscripts by religious reformers. While it is true that Merton, like other colleges, must have discarded hundreds of manuscripts by the end of the sixteenth century, the crucial factors are likely to have been simple lack of space, a wish to have a much more modern collection in the

Ego dixi in dimidio dierum meorum vadam ad portas inferi

Non aspiciam hominem ultra et habitatorem quietis

Generatio mea ablata est et convoluta est a me quasi tabernaculum pastorum

...est vita mea dum adhuc ordirer succidit me de mane usque ad vesperam finies me

sicut leo sic contrivit omnia ossa mea de mane usque ad vesperam finies me

clamabo... sicut pullus hirundinis sic clamabo meditabor ut columba

...Domine vim patior responde pro me quid dicam aut quid respondebit mihi cum ipse fecerit recogitabo tibi omnes annos meos in amaritudine anime mee

Domine si sic vivitur et in talibus vita spiritus mei corripies me et vivificabis me ecce in pace amaritudo mea amarissima

Tu autem eruisti animam meam ut non periret proiecisti post tergum tuum omnia peccata mea

Quia non infernus confitebitur tibi neque mors laudabit te non expectabunt qui descendunt in lacum veritatem tuam

Vivens vivens ipse confitebitur tibi sicut et ego hodie...

In order to protect large folio volumes, the text block was attached to oak boards. The parchment paste-down that would have covered the board of this volume has been removed, to reveal the bare wood and the edges of the leather that covers the exterior of the board. Marguerin de la Bigne, *Sacrae bibliothecae Sanctorum Patrum Tomus VIII* (Library of writings of the Holy Fathers) (Paris, 1589).

library, a feeling that some of the medieval scientific texts (so prized by later collectors) were out of date, the fact that many medieval scripts would have been illegible to sixteenth-century readers, and probably the poor condition and large number of 'duplicates' among the manuscripts in the circulating collection. The practice of holding elections and maintaining a separate large circulating collection appears to have died out by the end of the century. The entries in the 1556 list show that some of the same texts were held in both manuscript and print – and these manuscripts have survived to the present day.

Some of the discarded manuscripts were sold to local booksellers (the same men who were providing the printed books) or given to members of the college. Some were later purchased from booksellers by collectors and have gradually found their way to the Bodleian Library and other research libraries. The parchment in older manuscripts could also be sold for reuse. Bookbinders often strengthened bindings and covered the inside of wooden book covers with detached pages from medieval books. The remains of many manuscripts are thus coincidentally kept in college libraries in the form of recycled fragments in the bindings of many of the sixteenth-century leather volumes that give the Merton library its distinctive appearance to this day.

The sale of the silver enabled the college to make a big immediate change in the library, and it marked a departure from the previous Merton practice of relying primarily on gifts and bequests. Such donations continued to come in, but there was no regular funding for library books until 1572 when the college agreed that the sums of money paid by new fellows as a kind of admission fee, and which had previously been used to pay for a college feast, should henceforth be used to buy books for the library 'for the common use' of the members of the college.

Sir Henry Savile

When considering the growth of college libraries like Merton's, one has to bear in mind that the university library established in the fifteenth century had ceased to exist by the mid-sixteenth century. With no one to look after it properly, and no funding for new acquisitions, its holdings were stolen or totally neglected to the point of ruin, and in 1556 the furnishings were sold by the university. Every college that could afford it had to provide for its fellows and meet their needs for new books.

In the second half of the sixteenth century the Merton library changed its appearance and its collecting practices.

More accurate printed editions of older texts were pouring off the presses, and there was a great increase in new scholarship in fields like science and medicine. Most of these books were still written in Latin, and the majority were printed in Continental Europe. Warden Henry Savile instituted changes that enabled Merton to acquire newly published books and to house them.

Sir Henry Savile was thirty-six when he became warden in 1585, but by this time he had been a fellow of the college for 20 years. He had also travelled across Europe, visiting other libraries and scholar-collectors in search of texts not previously available and rare manuscripts to aid his own research. As tutor in Greek to Elizabeth I, Savile spent time at court, so he brought to Merton a more cosmopolitan outlook as well

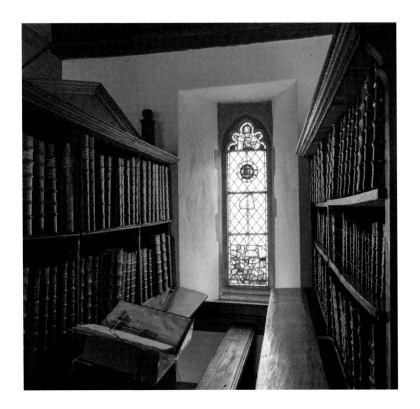

as great intellectual energy. John Aubrey, in his *Brief Lives*, records that Savile was described as 'an extrordinary handsome and beautiful man', although Aubrey also quotes a fellow of Merton who claimed that he was 'too much inflated with his learning and riches' (vol. 1, p. 264). Savile must have brought to the college a feeling that Merton needed to catch up to be at the forefront of the scholarly world.

The overall appearance of the library today is that envisaged by Savile. He took action in the early years of his wardenship, changing the administration of the library, the acquisition of books and the furnishings. In 1586 he renewed the library regulations, tightening security by revising the rules regarding the library keys issued to fellows. If a fellow failed to produce his key at an annual inspection, he had to pay a fine of thirty shillings (*c.*£300 today), and if he did not do this within two weeks, the amount would be withheld from his remuneration.

In 1588 Savile began a great refurbishment of the interior of the library. Beginning in the west wing, the medieval lectern desks were removed and replaced with horizontal bookshelves with a desk surface running beneath. In order to save space, a single bench provided seating for desks on either side. On the two shelves above each desk, the folio books were now stored upright on their bottom edges. At the time, this was a major innovation, and Merton is the first recorded use in Britain of this method of storing books. It seems likely that Savile

Etsi facilior sit, solis scriptis, ligamentorum ossa continentium explicatio, quàm vt picturis indigere videatur. Tamen, ne quid hoc loco praeter mittamus,quae magis insignia sunt ligamenta, his figuris descripsimus:in eorum gratiā qui vel minima quaeq; sibi ob oculos proponi cupiunt.

Numeri autem in margine designati : non quidem ad ligaméta, sed ad musculorum origines explicandas pertinent, quos deinceps suo loco interpretabimur.

Autre portraict d'vne femme d'Egypte, selon qu'elle
est acoustrée allant par la ville du Caire.

Dij

[opposite] James Leech bequeathed about 200 volumes to Merton. In addition to large legal tomes in Latin, his books reflect interests in French history, exploration and travel, such as Pierre Belon's illustrated account of his travels in Egypt and the Middle East in the 1540s, *Les observations de plusieurs singularitez et chose memorables* (Observations on several singularities and memorable things). (Paris, 1554), p. 106.

[right] Roger Gifford (d.1597), Junior Linacre Lecturer at Merton from 1561 to 1563, was later physician to Elizabeth I and president of the College of Physicians. His bequest of books included works on contemporary medical debates, botany and astrology. (An inscription in this volume of Arabic astrology reveals that Gifford purchased it for thirteen shillings on 10 December 1568 and commemorates his term as 'Master of Fools' at the Christmas festivities.) Haly Abenragel, *Liber de judiciis astrorum* (Book on the judgements of the stars) (Basel, 1551).

De capite & cauda draconis quid significent.
Caput VIII.

Caput uero draconis est fortuna naturaliter, & de natura masculina, sed per accidens, aliquando fit infortuna. Est enim natura eius composita de natura Iouis, & de natura Veneris, & hoc habet augmentationem atque significare res que augmentū suspiciūt, regnum scilicet & dignitates, & substātiam, & sublimitatē atque fortunā bonam. Et dixerunt Adila & Argafalā, quòd proprium capitis est augmē tare, præterquàm in datione annorum, minuit enim 12. partē earū cum fuerit cum significatore. Vnde cum fuerit cum for-

had seen a similar arrangement on the Continent, but so few libraries retain their sixteenth-century furnishings that one cannot with certainty point to a particular inspiration. Many more books could be stored upright side by side than flat on the desk surface. A similar stall layout with shelves and desks by each window was soon employed at other colleges and in Thomas Bodley's refurbishment of Duke Humfrey's Library a dozen years later. This is no coincidence. Bodley (fellow of Merton from 1563 to 1586) and Savile were firm friends, and Savile was to oversee the construction of the university library following Bodley's death in 1613.

In their new arrangement, the library books at Merton were still chained, but the chain was attached to one of the fore-edges, and the books therefore had to be stored with their fore-edge outwards. Each volume had its own numbered place on the shelf, and numbers or even abbreviated titles can still be found inked onto the fore-edge of some volumes.

The periodic elections of books circulating among the fellows died out in the course of the sixteenth century. The last election recorded at Merton was in 1519, but some circulation of these manuscripts may have continued in further decades, and a small percentage of the medieval circulating manuscripts were 'promoted' to be chained in the library in the mid-sixteenth century. It may be that before the renovations of the 1580s not all books stored in the library were chained. Borrowing from the chained library was an exception to the rules and a special privilege requiring the permission of the warden and senior fellows. In these cases both loans and returns were recorded in the college register.

Once the library could physically accommodate more books, they were acquired rapidly by purchase and bequest. At this time, most new academic books were produced in Continental European cities, and Savile supplemented purchases from English booksellers with several major purchases abroad. In a couple of instances fellows travelling abroad were authorized to buy books on behalf of the college and ship them back to England. Thomas Savile, the warden's brother, also a fellow of the college, purchased fifty-one books in Italy and at the Frankfurt Book Fair in 1589–90, sending them to the college in two batches. Several of these books were purchased in the year of their publication, demonstrating the wish to get the newest books as quickly as possible.

Fellows still donated prized individual books to the college. Because books were more readily available, some fellows began to build their own sizeable collections of books in their subject areas, and bequests and gifts of these personal

Sixteenth-century donations also included some fine fifteenth-century printed books, such as this copy of Vincent of Beauvais's encyclopedic *Mirror of History* with a hand-drawn coloured initial (printed in Venice, 1494), which came to the college with the Leech bequest.

⸿ Speculum Historiale Uincentii Usqz in suum tempus.

Cum additionibus historiaz annexis vsqz in tempus fere currens. videlicet. M.CCCC.XCIIII. Liber primus Feliciter Incipit

⸿ Prohemium.

IN Ultime Partis huius capite Speculi videlicet Historialis: placuit quoddaz historie naturaliz et omniu artiu atqz virtutum epitoma id est recapitulatione breué pmittere. Quatenus z pars hec sicut z relique ceteras vtri es cõtineat causa dicta in prologo generali exigere.

⸿ Epilog' de Unitate diuine substãtie. Cap. I.

DEus est substãtia incorporea, simpler z incommutabilis, imensa z eterna incomprehensibilis z ineffabilis. multifarie tñ vtcunqz nominabilis. Nam dicit breuiter quicquid, nihil tñ de ipo digne dici potest, sed eoipso iam indignus est, qõ dici pot. Nã verius quidem cogitat deus qz dicit, z verius est qz cogitat, z hoc solu videlicet esse de ipso, ppiissime tñ qñ omnia cetera cõparata, merito nõ esse dicunt, vnde ego sus ait qui sum, hoc nomẽ mihi est internu. Itaqz dicere quid est deus sm substãtia est impossibile, meliusqz innotescere poterit ex omnius rex ablatione. Negationes siquide in diuinis vere sunt, affirmationes autẽ incompacte. Nõ eniz est aliquid eoz que sunt, nõ, qz nõ sit non ens, sed qz super omne ens z sup esse existens. Ipse est enim vt ait dionysius. archanus bonu rationi omni superessentiale. vnitas vnifica omnis vnitatis supessentialis essentia: intellectus inuisibilis, inscrutabilis tãqz nõ ente vestigio vllo in occulta eius multitudine peruenientiu. non tñ incõmunicabile est bonu vlli eoz que sunt. Nihil enim naturaliter boni participatione priuatum est. ipa est ratio simpla z vere existens veritas, circa qua vt puras z non errante scientia diuina fides est vnicum credentiu fundamentu, eos collocans veritati z eis veritatem. Ipsa est substantia adunatrix cognoscentium cognitoz restituens a malo: magis autẽ statuens in bono, ordinans z omnes z integritate perficiens, z omniu maculas soluens. Ipse est z ait greg'. nazanzenus cuius esse totum est insuperabile quoddã fine fine substantie pelagus, nullis terminis limitibusqz circundatus. omnes sensum omnẽ naturã, omne tempus supergredies. Ipse est vt ait Aug. quẽ amat omne qõ amare potest siue sciens siue nesciens. Ipse est quẽ nemo amittit nisi deceptus, quẽ nemo querit nisi admonitus, quẽ nemo inuenit nisi purgatus. Ipse est cui nos fides excitat. spes erigit, charitas iungit. Ipse est p quẽ omnia, que sine eo nihil essent, tendunt ad esse, ipse est qui mali nõ facit. z facit esse ne pessimu fiat. Ipse est õ cuius regno lex etiã in ista regna describit, cuius legibus arbitriu; animẽ liber est. bonisqz pmia z malis pene sirio p omnia necessitatis distribute sunt, cuius legibus in euum stantiu mot' instabilis nec mutabiliu perturbatus esse nõ sinit freniszq, circeuentium seculoz semper ad similitudinẽ stabilitatis reuocat. Ipse est p quem vniuersitas etiã cu sinistra parte pfecta est, ipse est in quo sunt omnia: cui tñ vniuerse creature nec malitia nocet, nec error errat. De niqz ipse est vt ait beatus Bern. qõ ad vniuersum spectat: finis, qõ ad delectatione. salus. qõ ad se: ipse non. ipse est nõ minus puerorum pena: qz gloria humiliu. Est eniz rationalis queda equitatis directio incõuertibilis atqz indeclinabilis quippe attinges vbiqz. cui illisa omnis prauitas conturbet necesse est, sed lõgitudo pp extrenitatẽ interminabilẽ. latitudo pp charitatẽ immensurabilẽ sublimitas pp maiestatẽ inattingibilẽ. profundu pp sapientiaz inscrutabilẽ hunc sancti sm aplm comprehendut. Porro vt ait scõus phus ipse

est immortalis mens incõtemplabilis celsitudo. forma multiformis incogitabilis inquisitio. insopitus oculus. omnia continens lux. bonum. Hunc etiam volens sicut poterat cicero diffinire. Mens quedam est inquit soluta z libera. ab omni concreatione mortali: secreta omnia sciens z mouens: ipsaqz predita nutu sempiterno. Empedocles quoqz sic eum diffinire fertur. Deus est sphera cuius centruz vbiqz. circunferentia nusqz. hic vtiqz corpore non eget vt sit nec loco vt alicubi. nec tempoze vt aliquãdo. nec causa vt aliunde. nec formã vt aliud. nec aliquo genere subiecti in quo subftet vt cui assistat. Deniqz mutari omnino non potest. neqz enim potest augeri qui immẽsus est. neqz minui qui vnus e. fnec loco mutari qui vbiqz est. nec tempoze qui eternus est. nec cogitatione qui sapientissimus est. nec affectu qui optimus est.

⸿ De Trinitate Personarum Ca. II.

Uunqz sit omniuz deus excelsus inaccessibilis. omniqz virtute inestimabilis. vnus est in substãtia. trinus in psonis. vnus quidẽ est: ne differentia cõtrarietate: z cõtrarietatis pugnã. pugnavero corruptionem inducat: trinus vero ne solitudo vel singularitas eum vel minus potẽte: vel minus bonu: vel minus etiã felice oftendat. Pater nãqz fontalis omniq bonitas: qz potuit z voluit filium dilectum genuit, cui beatitudinis sue delicias plenissime cõmunicauit. nõ eniz inopi dando subueniti sed ipsam copiã genuit: alioquin beatius esset dare qz accipere. Ac p hoc sibi p omnia coequale genuit: ne ft hoc nõ poffet: infirmus: z nollet: inuidus videret. Sed z coeterni genuit: qz nunqz sine illo fuit. Ne autem sine generatione imperfect' aut post generatione (subaudi natus) arguat: consubstantialem quoqz ne diuinitatis substantia duplicet. Dic est sapientia: veritas z verbu: figura z splendor patris eius: imago pfectissima p quã ipse secretissimis diguis animis innotescit: p hunc etiã omnia digna fecit: non quasi p organu ministrale: sed naturali z subsistẽte virtute: sicut ignis lucet eo qõ lucere pueuit lumine. Et qñ in deo nulla indigentia est: ac p hoc etiã nulla in eo necessitas est: pzire autẽ voluntas sapientiã nõ põt: nec voluntate pcedente pater filiu genuit: nec vlla necessitate: fz semp manente bonitatis plenitudine. Ne autem immoderata esset diuina generatio: filiu nõ genuit sed ex vtroqz spiritussanc' pcedit vt ambo se mutuo diligetes: tertiu quoqz condilecti haberent. cui charitatis sue delicias oĩo cõmunicaret: in quo etiã vel p quẽ creature rõnales pro modulo sue capacitatis eisdẽ participarent. Ipse eniz sm aug. charitas vtrunqz coniungens: nosqz subiungens: qui igit ad summu bonu pertinet z summa pfectio z summa iocunditas filius a patre pcessit p modu generationis: z p emanatio pfectissima: z spsfanc' ab eodẽ p modu liberalitatis. Dic est iocundissima atqz gratissima: nihil eni est iocudius qz diligere z vfqz simulqz delicis frui cõibus: nec vllius boni possessio iocuda est fine socio. Piimu autẽ z pcipuu liberalitatis donu: in quo z cetera cũcta donant amor est: omnia eniz amato gratis cõicant. A fonte igit bonitatis qz pater est. pcedit donu amoris qui spsanctus est. Si autẽ a pre cõsequenter z a filio: qz pater nihil sibi retinuit: qõ filio suo gignendo dederit: sicut ipse ait. Omnia qz hz pater mea fut: pptere dixi qz de meo ac. z anũ. vo. Est autẽ spsanctus equalis vtriqz: qz ex summa liberalitate oportuit summu donu pcedere: quo z summus bonu. Est etiã deus qz donu intrinsecũ est: z quicquid est in deo deus est. Ob h vtriqz coeternus est: qz donu intrinsecũ pzius in deo fuit qz esse vel aliud quicqz creatur cõicaret exteri' z distribueret. Tẽpus autẽ z creatura coeua fut. Est autẽ vnicus in substãtia: multiplex in donis: qz diuisiões gratiaz sunt. Idẽ autẽ z ipse vt. Exẽpli quidẽ trinitatis vni' substãtie: nulli in creatura satis exprssuz inuenif ob h tñ in igne maxie deus apparuisse legit: qz in eo trina.f.ignis splẽdor. z calor sil cõftitut. z vnũ lumẽ sunt: qu cũ inseparabiliter operatur: igni tñ attribuif vstio: splẽdori illuminatio: calou calefactio.

⸿ De Cõmunitatibus z ppzietatib' personaz. C. III.

HIc autem tota trinitas sui pfectione equalis est: vt exceptis ppzietatib' psonalibus: quicquid de vna psona dicit: oigne se trib' itelligatur nec maior i oibus psonis: qz in singulis: sz tãta i solo patre. vel i solo filio: vel in solo spsancto. quãta in patre simul z filio z spsancto: nã z christus vna psona est: gemine substãtie: deus z homo.

⸿ ⸿ a

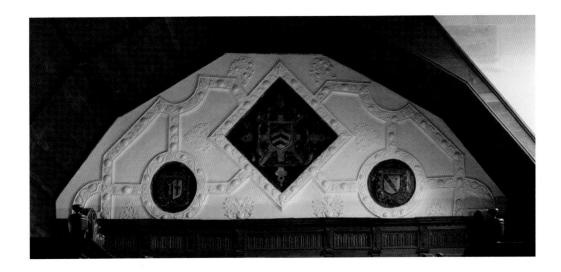

collections also updated and added depth to the college library in the last decades of the sixteenth century. Thus Merton acquired important medical works from the libraries of the early Linacre lecturers in medicine, Roger Gifford and Robert Barnes. Such major bequests were probably intended to benefit both the college and the successive holders of the lecturerships, in much the same way that Henry Savile later donated extensive collections of books to form the basis of subject libraries for the post-holders of the Savilian chairs that he founded in the university.

A bequest that came just as the college was renovating its library (and which Savile may have anticipated), was the collection of James Leech (fellow 1555–67; d.1589). Leech worded his bequest to avoid duplicating any books already in the library and restricting his gift to books in folio and quarto formats (the larger sizes, which could be easily chained). His donations were 'to remain for ever in the said Librarie as other Bookes are there usuallie putt, sett, and chained' (MS. E.2.2). The many expensive legal works in Leech's collection would have helped meet the need for new editions in this important subject area.

The decorative plasterwork at the end of both wings features the shields of the warden and college visitor (the archbishop of Canterbury) flanking those of the college. Such plasterwork was in fashion at the time, and had the advantage of increasing the light in the room. The west wing features Archbishop Whitgift and Warden Savile. The south wing features Archbishop Abbot and Warden Brent.

Medieval floor tiles were acquired second-hand to cover the library aisles as part of the completion of the renovations in the early seventeenth century. Some tiles retain decorative glazing such as this rabbit.

Even after Leech's bequest Merton's law holdings may still have been considered a bit weak, however, because in 1599 the college spent the large sum of £110 to purchase the legal books from the library of John Betts, a fellow of Trinity Hall Cambridge. These included civil and canon law editions and major commentaries.

The renovations of the Merton library were continued when the longer, south, wing of the library was converted to the stall system in 1623. By the time of the completion of this second phase of refurbishment, the library must have appeared truly 'renewed' within its medieval space. With the construction of a large oriel window in what had previously been a separate room at the east end of the south wing, along with four new dormer windows in the ceiling, the library became more light and spacious. Decoratively carved wooden screens at the entrance to each wing, aisles covered with medieval glazed tiles and the panels of decorative plaster work provided a harmonious and elegant setting for the updated library collection. During Savile's wardenship, the library's holdings of printed books tripled in size, to about 1,000 books. His plan to renovate the library furnishings was completed by his successor, Nathaniel Brent, but the account in the college register makes clear that this was Savile's project.

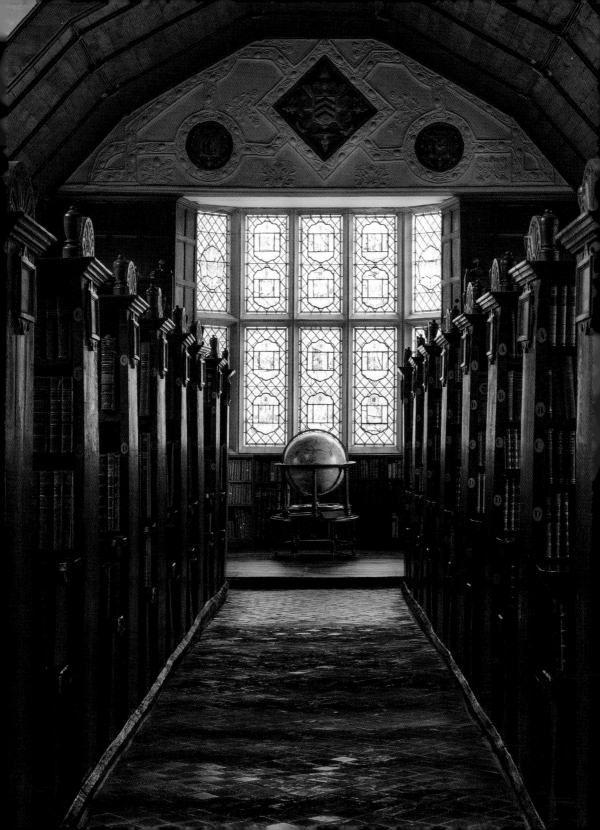

Seventeenth century 4

Librarians and trophy books

M embers of the college, even those not directly involved, could not have failed to be aware of the renovations in the library in the first decades of the seventeenth century. The library building was a source of collegiate pride, attracting periodic donations of money and of books that were rare and/ or costly, particularly in the second half of the century. The library was an integral part of the business of the college. Access to the library was one of the privileges of fellowship (whether that privilege was used or not). The annual surrender and reissuing of the fellows' keys to the library, the practice begun by Henry Savile in 1586, is recorded in the college register at the start of every academic year. This ceremony had a very practical function, since the college needed to control access to a room that was not constantly supervised, but it had also become one of the rituals that shaped the college year, similar to the service commemorating the founder.

Because the books were chained, there was no need for a loan register. The very occasional borrowing of books, usually by eminent scholars such as Archbishop James Ussher or by fellows of the college, involved unchaining and rechaining.

View of the south wing.

When Thomas Jones, a fellow, borrowed a two-volume illustrated history of ancient Italy in 1657, it was duly recorded in the college register, as was the return of the volumes in 1658. Since this book is still in the library such care seems to have been effective.

The Civil War (1642–51) brought major changes to the city and university, particularly in the years 1643–6 when Oxford served as the royal capital. In 1643, coming to Oxford to join her husband, Queen Henrietta Maria took up residence at Merton. College life went on around this disruption. The fellows had to hold their periodic meetings in the library as most college spaces were given over to the queen's court, followers, servants and dogs. With the library behind lock and key, however, there was no damage to the room or the holdings, as there was to the chapel and to the hall, which was described as a squalid and ruinous place by 1646. The only regrettable loss from the library attributable to the war was the pair of sixteenth-century globes, which had been loyally lent to Christ Church for use by the young duke of York (the future James II) and which were never returned. Perhaps they were packed up along with royal belongings. Fortunately, books could not be melted down, so the library did not suffer the same fate as the college's silver, which was patriotically donated to support the royalist cause.

A cup or a book?

The college continued to support purchases for the library both from the fees paid by new fellows (the practice established in 1572) and from bequests, such as that from Thomas Allen (former fellow and Greek scholar) in 1641, from which the college bought unspecified books in Hebrew, Greek, Latin, Arabic and Persian.

Students provided another source of income for the library. In the seventeenth century, especially after the restoration of the monarchy in 1660, Oxford colleges admitted a category of

In 1657 the college register records the gift by the fellow and subwarden John Powell of a copy of the first complete Bible printed in Welsh. The translation was undertaken by William Morgan and others, based on Hebrew, Greek, Vulgate (Latin) and English (the Geneva Bible) versions. In some ways this translation was a forerunner of the Authorized Version of 1611. *Y Beibl Cyssegr-lan* (Holy Bible) (London, 1588).

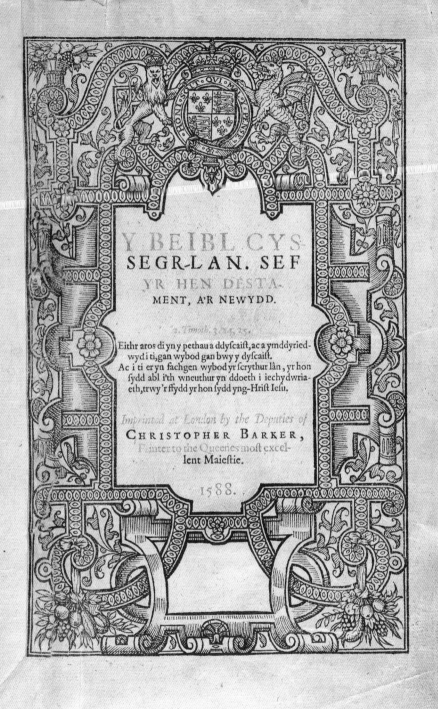

Y BEIBL CYS-
SEGR-LAN. SEF
YR HEN DESTA-
MENT, A'R NEWYDD.

2. Timoth. 3 cap. 25.

Eithr aros di yn y pethau a ddyfcaift, ac a ymddyried-
wyd i ti, gan wybod gan bwy y dyfcaift.
Ac i ti er yn fachgen wybod yr fcrythur lân, yr hon
fydd abl i'th wneuthur yn ddoeth i iechydwria-
eth, trwy'r ffydd yr hon fydd yng-Hrift Iefu.

Imprinted at London by the Deputies of
CHRISTOPHER BARKER,
Printer to the Queenes moft excel-
lent Maieftie.

1588.

Quarta Impreſſio ornatiſſima: continens omnes
Galeni libros alꝰ impreſſos: melius ꝗ3 prius
ordinatos: τ magis ꝗ3 antea emendatos.
Emittenſꝗ3 alios eiuſdem libros nun-
ꝗ cum alijs impreſſos: impreſ-
ſione tamen dignos / doctri-
nam ipſius decorãtes atꝗ3
perficientes: in tertio
volumine nouiter
imprimendo
contentos.
✠ ✠ ✠
✠

. Cum gratia ✠ Et priuilegio

Ex dono Hellenæ Gulſton, Uxoris Theod. Gulſton, olim huius
Coll. Socij
Aº 1635.

The tradition of Linacre lecturers in medicine leaving collections of important medical works to the college continued into the seventeenth century, with the gift from Helena Gulston of the books of her husband, Theodore Gulston. Gulston (elected fellow of Merton 1596; d 1632) was a gifted classicist and physician who studied the early texts of Galen. The 120 books from his library include both early printed works and more recent medical publications. *Primum Galeni Volumen* (first volume of the works of Galen) (Pavia, 1515).

undergraduate known as 'gentlemen commoners'. These wealthy young men paid higher fees, usually ate better food at a separate table, and were required to do very little academic work. They were also required to present a piece of silver of at least the value of £8 when they joined the college. At Merton and at several other Oxford colleges they had the alternative option of donating £8 for the purchase of books for the library. This was a particularly useful source of income, since the amount was more than double that paid by new fellows and, although Merton only took a couple of such students a year, their turnover rate was potentially higher than that of new fellows.

The wording of the seventeenth-century donation inscriptions differs from those from the Middle Ages and the sixteenth century. The earlier inscriptions may have specified that the book be chained or asked the reader to remember the donor through prayers. The standard inscription for a student's donation in the second half of the seventeenth century gives the donor's name, his father's name and status, his place of origin and his status in the college (gentleman commoner or commoner).

It is telling that the inscriptions on the silver tankards, cups and bowls of this period are structured in the same way. It is not clear whether these inscriptions in books record a purchase from the fee paid by the student or whether the student gave actual books. The donation inscriptions are reminders that the library and the common table were both places to demonstrate membership of the community and social status in a way that would be visible to future Mertonians. And one has to remember that in this period, even if the donor were a diligent student, he himself would not enjoy the books donated, as students had no access to the library.

Griffin Higgs and the position of librarian

As a young fellow, taking his turn as college bursar, a theologian named Griffin Higgs signed off on the expenses

incurred in the final stages of the college library refurbishment in 1623. Perhaps his involvement in this project inspired him years later to create a bequest that would establish the post of librarian as a college officer and reform the administration of the library.

Griffin Higgs (1589–1659) is not famous for his published scholarship or his actions on the world stage, but the course of his career influenced his bequests to Merton. Higgs was elected to a Merton fellowship in 1611 following undergraduate study at St John's College, Oxford. At Merton, Higgs held several college offices and the university proctorship before accepting a college living in 1625. (A living, or benefice, is a parish to which the priest is appointed by a patron, who could be a bishop, an individual or, as in this case, an institution such as a college.) A major event in his life was his appointment as chaplain to Elizabeth Stuart, queen of Bohemia, known as the Winter Queen. Higgs spent the years 1630–38 at Elizabeth's court in exile in the Netherlands.

[above] This large silver cup, known as an ox-eye cup, is typical of those donated by gentlemen commoners in the seventeenth century. The elaborate inscription informs the viewer that it was given to the college by George Pudsey from Elsfield, near Oxford, in 1680.

[opposite] Portrait of Elizabeth of Bohemia (sister of King Charles I and wife of Frederick V, the elector of Palatinate) from the studio of Gerrit van Honthorst. Elizabeth and her husband reigned as king and queen of Bohemia for one winter, hence the designation 'Winter Queen'. National Portrait Gallery, London, NPG 511.

During this period he obtained his doctorate of divinity at the University of Leiden and collected hundreds of books in that city, which was known for publishing and scholarship. In 1638 Higgs returned to England and to a position as dean of Lichfield where later he managed to survive two sieges by the Parliamentarians. Back in Oxford in the 1640s in retirement, Higgs was one of the candidates for the wardenship of Merton in 1645, which was eventually awarded by the king to his personal physician, William Harvey. At the time of his death Higgs was well-to-do and able to bequeath funds for the purchase of books to St John's, the Bodleian Library and Merton. A much bigger bequest of £1,000 to Merton was to provide support for students and for a divinity lecturer, and to endow a college librarian.

Higgs would have been personally familiar with a number of libraries and librarians (in Leiden Higgs knew the famous scholar librarian Daniel Heinsius). The establishment of the position of librarian by Higgs's bequest of 1659 was relatively late in comparison with other Oxford and Cambridge colleges (his undergraduate college, St John's, already had a librarian in 1603), but the description of the librarian's duties prescribed by

[above] Only one book, clearly a prized possession, was mentioned individually in Higgs's will as a gift to the college: a copy of the Book of Common Prayer and Bible in one volume, presented to him by Elizabeth, queen of Bohemia. Although, from its worn appearance, it would seem that the book was not as treasured by the college as it had been by Higgs, the gold-stamped decorative binding with the royal arms is still impressive. *The Holy Bible* (London, 1633).

[opposite] The elaborate red and black title page of the Book of Common Prayer and Bible. *The Holy Bible* (London, 1633).

יְהֹוָה

THE HOLY
BIBLE
Conteyning the Old
Testament and the New

Newly Translated out of ye Originall tongues
and with the former Translations diligently
compared and revised by his Maiesties
speciall Commandement.

Appointed to be read
in Churches.

Printed at London by Robert Barker
Printer to ye Kings most excellent
Ma.tie and by the Assignes of
Iohn Bill

Anno 1633

SOLVS. Isaiah cap. 63. EGO
CALCAVI TORCVLAR

Higgs is unusually detailed and provides information about the librarian's role within the college context.

Higgs's instructions about the duties of the librarian, transcribed in the college register (August 1672, MCR Register 1.3, pp. 487–8), can be divided into four parts: (1) the eligibility and appointment of the librarian; (2) the administration and care of the books and manuscripts; (3) encouragement of benefactions to the library and recording of such; (4) research into the college's own history. They can be summarized as follows.

The librarian was to be elected by the warden and five senior fellows from among those already in the fellowship who had attained a Master of Arts and had been fellows for at least four years. A stipend of £10 per year was to be paid in termly instalments and, unlike some college offices that changed annually, the librarianship could be held as long as the librarian retained his fellowship. Higgs also made provision for how the librarian could be removed from office in case of neglect of duties, following three warnings.

In the second section, it was assumed that the books were chained in the library and arranged by subject. The librarian was to assign books to their subjects and to draw up full alphabetical and subject catalogues. Lists of contents were to be prefixed to each of the manuscripts, 'so that printed lists of them may be made'. This may indicate an awareness that some of the medieval contents lists were no longer accurate following the seventeenth-century rebinding or that it was difficult to read medieval scripts. Higgs's wording, 'in order that, not moth and worm, but bright intelligences, may be fostered by them [the manuscripts]', indicates that the record-keeping was not just for inventory but in order to make the library more useful for researchers. The librarian was also to advise the warden and fellows on the purchase of books from the library funds, rather than to have a free rein on library spending. Unlike some seventeenth-century librarians, Merton's librarian was not

One of the duties of the Merton librarian was to add lists of contents at the beginning of all the manuscript books. Here a slip of paper with the contents was pasted inside the front board of MS. 47 in the seventeenth century. The list begins in a formal hand, but after item 5 it is completed by a different person in a much more informal script. The remaining cotton tie has been secured to the bottom of the board by a twentieth-century conservator. MS. 47.

THE N1296240

SOULDIERS

EXERCISE:

IN

THREE BOOKES

Containing moſt neceſſary and
curious rules for the exact muſtering both of
Horſe-troopes, and Foote-bands, with
ſeverall formes of Battailes deſcribed
in Figures.

A worke fit to bee ſtudied, and meet for the
knowledge of Captaines, Muſter-Maſters, and all
young Souldiers, and generous Spirits that
love the Honourable Practiſe of
Armes.

By
G. MARKHAM.

LONDON,
Printed by *Iohn Norton,* for *Iohn Bellamy, Hugh Perry,*
and *Henry Overton.* 1639.

[left] Griffin Higgs bought books and pamphlets in many subjects. There are pamphlets relating, not surprisingly, to the Civil War, the execution of Charles I and theological works, but also to history, travel and other academic subjects. Many of these were small-format books, not expensive collectors' items. Higgs read many of them, underlining passages and marking the margins. Gervase Markham, *The Souldiers Exercise* (London, 1639).

expected to organize a regular inventory or to replace at his
own expense any books that had gone missing during the year.

Inspired perhaps by Thomas Bodley, Merton's new librarian
was to be proactive in encouraging 'distinguished persons in
Church and State', and especially, but not exclusively, those
educated at Merton, to bequeath something appropriate to the
library. A 'sumptuous' (*pulcherrimo*) parchment register (of the

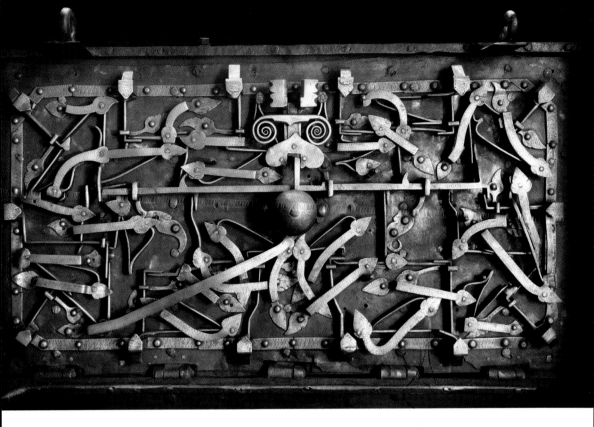

[above] The open lid of the German chest purchased in 1613 by the college from a bequest by Thomas Bodley reveals a magnificent locking mechanism. It is unknown when it was transferred to the library.

kind already in use in the Bodleian and many college libraries) was to record the names and the gifts or books purchased with bequests. As a former fellow, Higgs would have known that significant bequests to the library were recorded in the college register, but a donor was unlikely to be impressed by their gift being mentioned in the often scrawling entries in a large paper volume that was definitely not for display.

Up to this point in Higgs's document, the understanding of the librarian's role is similar to that in other colleges and universities, but Higgs had in mind that the Merton librarian would also conduct research into the history of the college – not just in the college records but elsewhere as well. The librarian would be a kind of historian along antiquarian lines, gathering source material for publications on the lives of great

Mertonians. The seventeenth century was a period when antiquarian research flourished in England. Higgs himself, as a young man, had composed a verse life of the founder of his undergraduate college, St John's. He also owned a copy of an illustrated printed book celebrating the great men associated with the University of Leiden, which may have been a model for him.

Higgs complemented his establishment of the librarianship by bequeathing his own library of some 650 volumes, forming the largest single donation of books up to that date. It took a while for the college to arrange to take possession of the books. Higgs's books had been sequestered by Parliamentary authorities after the surrender of Lichfield (1646), and, although he managed to redeem them for a fee, the books were subsequently stored in several locations, only some of them coming to Oxford with Higgs. A significant number were

Higgs purchased many of his books from local booksellers and at auctions during his time in the Netherlands. Several of the small-format catalogues of these sales came to Merton along with his books. From the marked-up pages of the catalogues, one can imagine Higgs eagerly deciding which items were most interesting to him. *Catalogus variorum librorum* (A catalogue of various books) (The Hague, [12] April 1633), C1v–2r.

sent for safekeeping to Stafford, and it took several years and the threat of a lawsuit for the college to retrieve them in 1665 (some six years after Higgs's death). Similarly, the £1,000 legacy was from an assigned debt, so that the money was received only in 1664. Even then there was a delay in realizing Higgs's plan, since initially the college made a personal loan of the entire sum to the warden, only appointing Robert Huntington as the first Higgs Librarian in 1667 when the warden had repaid the money.

The establishment of the position of librarian, although noted twice in the college register, did not apparently make an immediate difference to the administration of the library at Merton. The last third of the seventeenth century did see developments that put many of Higgs's wishes into practice, however, and there is evidence that the library collection was a focus for scholarly work and that certain gifts were seen as enhancements to the community.

Developments in the administration of the library collections

Most of the seventeenth-century initiatives relating to the care and administration of the library are difficult to date. There are regular modest payments each term for someone to clean the library. A major programme to rebind many of the manuscripts took place sometime after 1615, probably in the first half of the century. The binder who supplied these brown reverse calfskin (suede) bindings to Merton and to other colleges did not take much care over the contents, since marginal annotations, donation inscriptions, decoration and sometimes even parts of the text were carelessly trimmed away. At some later point, sheets of paper with a list of contents were pasted on the inside front cover of each manuscript just as Higgs had directed. Similarly, donation inscriptions were added to the title pages of most of the volumes bequeathed by Higgs. There are periodic references in the college register to catalogues, and there must have been shelf lists to help fellows locate books. The bursars'

accounts for Trinity Term 1665 show that a payment of £1 was made for the writing out of a library catalogue. Similarly, accounts for 1693 record that someone named Barker was allocated £5 8s. 9d. to make a catalogue of the manuscripts as well as a transcription of the college statutes for the new warden. If they were ever completed, these catalogues seem not to have survived.

Like many smaller libraries, Merton solved the author catalogue problem by making use of the printed catalogue of a larger library – in this case the Bodleian. The Merton copy of the alphabetical catalogue of the Bodleian Library, published in folio format in 1674, was rebound in two large volumes, with a blank page interleaved between each printed page. If Merton possessed a copy of an edition already held by the Bodleian, the Merton shelf mark was added by hand next to the relevant entry. Entries for Merton books not owned by the Bodleian were written on the blank pages opposite where the entry would occur in the alphabetical sequence. It likely that at least some of these library activities in the second half of the century were inspired by a wish on the part of the early

At some point in the seventeenth century, many of the medieval manuscripts were rebound in a uniform style. The workmanship is serviceable, replacing the older wooden boards with paste-board covered in reverse calfskin, giving a suede effect. Instead of clasps, these volumes have cloth ties (the blue dye is still visible in this example). The traces of the chain attachment are still visible at the edge of the board. MS. 197.

The 1674 Bodleian Library Catalogue was repurposed as the college library catalogue. The entries in different hands show that this catalogue was in use into the early nineteenth century. Thomas Hyde, *Catalogus impressorum librorum Bibliothecæ Bodleianæ* (Oxford, 1674).

Higgs Librarians (as they were called in the register for several decades) to fulfil their benefactor's instructions. Perhaps there was also an awareness that catalogues designed to help people use the library (as opposed to lists for inventory purposes) were becoming increasingly common in academic libraries.

Robert Huntington and donations of exotic scholarly books

The first fellow to be appointed as Higgs Librarian was Robert Huntington (d.1701). His love of learning had been noteworthy even at a young age, as he was said to have been the first boy to get through Bristol Grammar School without once having been whipped. Huntington studied theology and Middle Eastern languages at Merton, becoming a fellow in 1658. He had held a series of college posts (Greek lecturer, dean, bursar) before his appointment as librarian in 1667. Much of his librarianship

was held in absentia, however, as he left for Aleppo in Syria in 1670 to take up a position of chaplain to the Levant Company. The college generously allowed him to retain his fellowship and the position (and pay) of librarian. Although an absentee librarian does not seem like a good start for a first post-holder, it was this period of travel that enabled Huntington to make a unique contribution to the Merton library.

Huntington was based in Aleppo for eleven years. In many ways, this was his dream job. In addition to fulfilling his duties to the Levant Company and to local Anglicans, Huntington travelled widely and sought out contacts in the Muslim and Jewish communities. He collected books and manuscripts, both for himself and on behalf of other scholars in Oxford. He did not forget Merton either. In 1673 the college register records with some excitement the arrival of a shipment of thirty-two books and manuscripts 'bought for no mean sum from the hands of barbarians' and given by Huntington to the college library out 'of his generosity and his great devotion to his homeland' (MCR Register 1.3, p. 503). This description reveals that, for the majority of Merton fellows, the civilizations of the Middle East were still considered alien and exotic. Huntington's friend and fellow of Merton Nathanial Wyght carefully checked and sorted the lists of the contents of the crates of books that came from Aleppo and Damascus. Possibly Wyght took care of other aspects of library administration in Huntington's absence.

Robert Huntington returned from the Middle East in 1682, and left the college in 1683 to take up the position of provost at Trinity College Dublin. He made a number of gifts of books and antiquities to the Bodleian, the Ashmolean, and later Trinity College Dublin, and over 600 of his manuscripts in Turkish, Arabic, Hebrew, Syriac, Persian, Coptic and Samaritan were eventually sold to the university for over £1,000. The Bodleian was an attractive prospect for members of the university seeking a home for their valuable

[opposite] The title page of David Kimhi's *Sefer Mikhlol*, a detailed Hebrew grammar, printed in Constantinople in 1532–34. Huntington's ownership inscription and collection number are written in ink at the top of the page. Although only a few items from Huntington's important collection came to the college, he seems to have made a careful choice, providing the college with rare early editions in print of works on theology and the Hebrew language.

scholarly collections, as the books would then be available to a wider scholarly audience (and the college was unlikely to have paid such a princely sum).

Trophy donations

In Huntington, Merton had a learned and respected librarian with a wide circle of friends. He was not a hands-on librarian in the way that Bodley's Librarian was, but he represented an attitude to the college library as a fitting place for special items of great value to scholars. This attitude appears to have been shared by several of his contemporaries at Merton. The last three decades of the seventeenth century thus saw the presentation to the library of a number of high-status items, some from fellows, but others from men who had no direct connection to the college but were possibly personal acquaintances of Huntington's. Among these significant gifts were the *Herbarium Vivum* (Living Herbal), given by the fellow Charles Willoughby in 1673; four manuscripts in Turkish and Arabic from William Fane, nephew of the first earl of Westmoreland (in 1675); and a set of magnificent Blaeu atlases from Peter Vandeput (in 1684). Were the gifts from Fane and Vandeput the result of

Hieracium alprestre maximum.

22

23

hirsutum majus

medium

24

minus

25

Higgs's request that the librarian actively solicit gifts from 'distinguished persons in Church and State'?

A number of volumes (sixteen printed books and one manuscript) that could be described as 'of bibliographical interest' were donated in 1680 by the then warden, Sir Thomas Clayton. Clayton, an ambitious physician and member of parliament, had been appointed warden in a bitter contest that was settled by the archbishop of Canterbury in his role as college visitor. Many fellows felt that Clayton had been forced on them, and initially they refused to let the new warden into the gates of the college. Clayton continued to cause periodic unhappiness among the fellowship, and when he died after 31 years as head of the college, a note in the college register records that he left to the college '£00. 0s. 0d.'. Almost all wardens since the thirteenth century had presented at least one book to the library. The selection of books donated by Clayton suggests that he chose 'special' books rather than current publications for academic use. Some were printed in the sixteenth century and were illustrated with woodcuts. In addition to medical texts such as one might expect from a physician, there is some law, natural history, topography and theology. There are also some striking bindings. Warden Clayton is not known to have been a book collector, but his father, also Regius professor of medicine, had bequeathed medical manuscripts to the Bodleian, and other valuable books owned by him are now in several Oxford college libraries. It is possible therefore that the books donated by Warden Clayton were from his father's library. It is also a bit of a mystery that he chose to make his donation in 1680, as that does not seem to have been a significant year. Perhaps he was influenced by the other high-value and unique items donated to the library in the previous decade.

If any book at Merton can be said to be a celebrity, it is probably the copy of the first edition of *The Canterbury Tales*, printed by William Caxton in 1475/6. The was the first major

سطر دله	١	٤		٦	٤	١
سطر باني	٤	١	٤٣	٣	٥	٨ ٨ ١
		١	٣	٨	٥	٩ ٥ ٢
			١	٦	١	٣ ٩
				١	٣	٢
سطر اله				٢	٩	٢ ١
سطر باله				٣	٩	٢ ٤
دله			٣	٨	٩	
مه		٣ ٤				
مم دد	١					

[left] Fane also gave the college an unusual Arabic prose translation of the Persian epic *Shahnama*, with a colophon date of 1495. Appended to the *Shahnama* is a history of the Ottoman sultans. MS. Or. 19, fol. 58v.

[opposite] The hand-illuminated borders of the opening page of Chaucer's 'Tale of Melibee' include brushes and Catherine wheels, both of which were devices associated with the London Haberdashers' Company. A smiling monkey climbs among the foliage. *The Canterbury Tales*, printed in Westminster by William Caxton in 1476–77, fol. 267r [quire 2L].

literary work in the English language printed by Caxton when he set up his press at Westminster. Few copies of this edition survive, and the Merton copy is unique in having borders painted by hand to mark the start of some of the tales. The decoration incorporates the coat of arms and heraldic devices of the Haberdashers' Company in London, indicating that the first owner may have been a wealthy London businessman. By college tradition it was a prosperous Oxford businessman,

A yong man that callyd was Mellebeus the whiche
was mighty and riche/begat a doughter vpon his
wyf that callyd was Prudence whiche dough-
ter callyd was Sophie/Vpon a day befyll the he for his
disporte wente hym in to the feldes for to pleye/His wyf &
his doughter hath he lefte wyth in his hows of whiche the
dores were fast shytte/Thre of his olde foes haue hit us
pied and setten laddres vnto the walles of his hows and
by the wyndowes ben entryd in/and bete his wyf/& woun
ded his doughter wyth fyue mortel woundes in fyue sondry
places/that is to saye in her feet·in her hondes·in her eeris·
in her nose·and in her mouth/And lefte her for ded and
wenten her waye/whan Mellebeus retorned was in to his
hous and sawe alle this myschief/he like a mad man ren
tyng his clothes began to wepe and to crye·

Prudence his wif as ferforth as she durst besoughte
hym of his wepyng to stynte/but not forthy he be
gan to wepe and crye euer lenger the more/This
noble wyf prudence remembrid her vpon the sentence of
Ouyde in his book that clepyd is the Remedye of loue/where
as he saith/He is a fool that distrobleth the moder to wepe
in the deth of her child/til she hath wepte her fille as for a
certayn terme/And than shal a man do his diligence wyth
amyable wordes her to comforte/And praye her of her we-
pyng to cese/For whiche reason this noble wyf prudence
suffrid her husbond to wepe & crye as for a certayn space
And whan she sawe her tyme/she said to hym in this wise
Allas my lord sayd she why make ye your self for to be

William Wright (*c.*1561–1635), who gave the book to the college in the early seventeenth century.

A snapshot of library acquisitions in the 1690s

The seventeenth-century donations of impressive individual books and scholarly collections attracted attention at the time and remain special items in the library today. But the college was also continuing to purchase books for the library from the fees paid by probationer fellows and new students, as mentioned earlier. A snapshot of this activity is provided by the library's Benefactors' Book (MCR F/6/3/8) which dates from the tenure of John Edwardes (1687–1694). He was the third Higgs Librarian, John Conant having held the position from 1683 to 1687. Edwardes may have been mindful of the instructions of Griffin Higgs about acknowledging benefactors appropriately. Coming into use in 1692, the Benefactors' Book is indeed made of parchment, with calligraphic script and initials illuminated in an amateurish hand. The volume thus makes an attempt to meet Higgs's requirement that it be a 'sumptuous' book. It was originally maintained for only a brief period before a long pause, resuming in a half-hearted way in the nineteenth century. In fact the nineteen entries may reflect a single push by Edwardes to solicit donations from former fellows in addition to recording the routine fees paid by new commoners and newly confirmed fellows. The names of six students (all gentlemen

[left] Among the works donated to the college library by Warden Clayton in 1680 are three that were originally from the library of Julius Echter von Mespelbrunn, prince-bishop of Würzburg. This volume would have been shelved with its fore-edge outwards, since the fore-edge was gilded with the title at the top, Julius's name in the middle and the date of acquisition (1578) at the bottom. Echter's magnificent library was dispersed when the episcopal palace was captured by Swedish troops in 1631. Some 250 volumes from his library are now in English libraries. Jacques de Vitry, *Sermones in epistolas et evangelia* (Sermons on the Epistles and Gospels) (Antwerp, 1575).

[opposite] Another high-profile gift from someone not formally connected with the college was the five-volume world atlas *Le theatre du monde ou nouvel atlas* (Theatre of the world or new atlas), produced in Amsterdam by Joan Blaeu in 1647 and presented to the library by Sir Peter Vandeput, sheriff of London, in 1684. This was one of the finest atlases of the day. The colourful title page includes allegorical representations of the different continents.

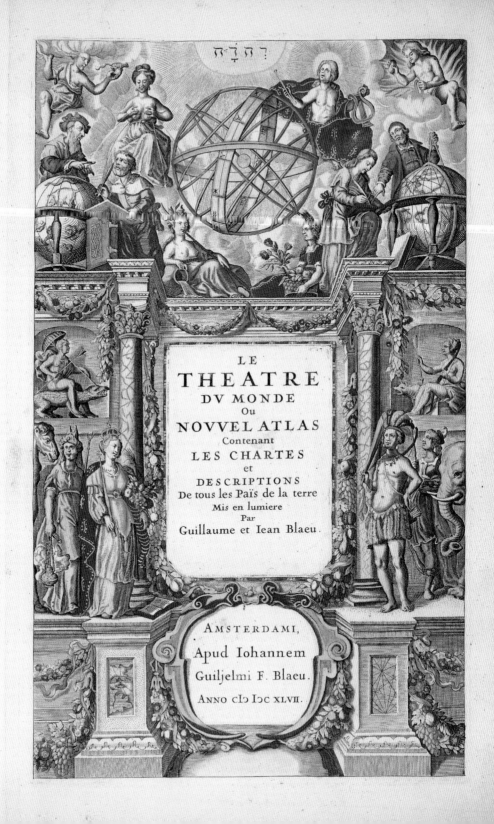

LE
THEATRE
DV MONDE
Ou
NOVVEL ATLAS
Contenant
LES CHARTES
et
DESCRIPTIONS
De tous les Païs de la terre
Mis en lumiere
Par
Guillaume et Iean Blaeu.

AMSTERDAMI,
Apud Iohannem
Guiljelmi F. Blaeu.
ANNO cIↃ IↃc XLVII.

ABurghers f.

The payment of £5 by Henry Pinke, 'fellow commoner' of the college, is recorded in the Benefactors' Book. His fee supported the acquisition of this 1688 folio edition of Milton's *Paradise Lost and Paradise Regain'd*. The engraved illustrations by Michael Burghers are striking, and it is tempting to think that this acquisition reflects a personal choice. John Milton, *Paradise Lost and Paradise Regain'd* (London, 1688).

commoners), nine new fellows and four former fellows are recorded, along with the amount of money they gave and the details of the books purchased. With the exception of the former fellows, the donation recorded was the standard fee of £8 for gentlemen commoners and £3 6s. 8d. for new fellows.

In total, the Benefactors' Book indicates that just over £100 was spent on the eighty-nine titles listed. A variety of subjects are covered, from Newton's *Principia Mathematica* (first edition of 1687), to medical works, editions of the classics, church history, European history and theology. Almost all of these works were folio format and many of them multivolume. There are a couple of entries that might have been less relevant to studies and more luxury items, such as David Loggan's lavish *Cantabrigia illustrata*.

As Merton went into the new century, the library had a respectable income in addition to having attracted some treasures over the course of the preceding decades. The position of librarian had been established as a college officer. It had been a productive time. But the following period brought some troubling developments for the library.

Eighteenth century

An 'old ruinous place'?

Unknown graduate of Merton College (National Gallery of Art, Washington), attributed to George Knapton, c.1754–55. This portrait of a fashionably dressed young man wearing a Master of Arts gown and standing in Christ Church meadow with Merton in the background allows one to imagine the sort of wealthy young fellow who would have enjoyed a cultured life at the college in the mid-eighteenth century.

In 1710 the aristocratic German scholar and book collector Zacharias Konrad von Uffenbach visited a number of Oxford libraries, including Merton's. His notes on his travels were later published as the *Merkwürdige Reisen durch Niedersachsen, Holland und Engelland* (Remarkable travels through Lower Saxony, Holland, and England), and an English translation of the section on Oxford appeared in 1928. His remarks about Merton are not very enthusiastic, although he appreciated the medieval manuscripts. Unlike many later visitors, he was unimpressed by medieval buildings. He wrote that the college

> consists of several ugly old buildings … The library is in two rather dark corridors and has a fair number of books. I found that the manuscripts were among the other books and therefore [decided to return] … there were a few astronomical instruments in a press, for which the key was not available. We were also shown an interesting skeleton. (*Oxford in 1710*, pp. 45–6)

Uffenbach does not say who acted as his guide, describing him only as a 'worthy Fellow of the college'. It is not clear whether the skeleton he mentions was kept in the library, although it may have been, since libraries at this time often housed unusual natural historical artefacts.

Even if one makes allowances for Uffenbach's personal taste (the airy Wren Library at Trinity College Cambridge, completed 1695, was more to his liking), it appears that the Merton library in the early decades of the eighteenth century was not the focus of great collegiate interest that it had been in the previous century. Few library records survive from this period, and it is difficult to know how much the library was used by the fellows for study. To understand the college library at this time, one has to keep in mind its place in the college's organizational structure, with the librarianship one of several desirable college offices. The library's distinct role was not often seen as very important, but it could be deployed as an element of college politics, and this is what happened in the feud between the warden and the fellows that took place in the 1730s.

In 1734 Robert Wyntle was appointed warden of Merton, while one of the unsuccessful candidates was John Marten, the librarian since 1719. Marten and Wyntle were exact contemporaries, both of them physicians. It was widely known outside the college that Marten expected to be appointed to the wardenship, since he had already served as subwarden. In his time at Merton (he had been there since his undergraduate days) he had seen two other college librarians become warden. It is no wonder that his disappointment fuelled a bitter dispute between Warden Wyntle and some of the fellows that finally ended with an archiepiscopal visitation and, for Marten, his ejection from the college.

Some of the more colourful anecdotes about the library in the first half of the eighteenth century come from a thick dossier of 'evidence' compiled by Warden Wyntle in making

his case to the visitor and bound into a volume now in the college archives and informally known as 'Warden Wyntle's Register'. Almost every area of college activity comes in for severe criticism, so it is hard to know how much is exaggerated. (A whole section of the dossier (MCR Register 1.6, fols 15–16), for example, concerns the question of whether the horses of some of the fellows had been eating hay that was for the warden's horses.) In his memorandum, Wyntle accuses Marten of living in Headington (then a village just to the east of the Oxford city walls) with his common-law wife and her mother (i.e., not in college where the librarian should live), neglecting the care of the library and misusing library funds: 'At present many persons have keys to the Library[,] the door is often left open. It is an old ruinous place that lyes [sic] in neglect.' The dossier continues:

> It is reported of [Dr Marten] that not long before the death of the late Warden [John Holland] the Dr would have some Logick books put out of the Library which the Warden thought proper should remain therein and upon this contest the Dr ordered the books to be throwed into the quadrangle from when they were taken up and carried in the Wardens Gallery where they now remain.
>
> Farther he hath at this time in his hands upwards of one hundred pounds of the Library money which he doth not lay out in buying of books. When he was occasionally at a meeting desired by the present Warden to deposit this money in the college Treasury till the proper books might be ordered to be bought with it, He gayly answered that his rents not coming in, he had spent the money.
>
> But the present Warden hath been since assured that this money is lent to some of the junior fellows to keep up his little Faction. ('Warden Wyntle's Register', MCR Register 1.6, fol. 158]

Finally, Wyntle asks the Visitor to determine 'What power the Warden of the College may be supposed to have over the Librarian and the Library?'

Some of these 'charges' may well have been true. Other sources confirm that John Marten kept a household in Headington with a woman to whom he was not married. During the first part of the eighteenth century the librarianship can be understood as just one college office among others that would bring its incumbent an additional £10 per year and which had no fixed term. At that time it could apparently be held concurrently with other offices – John Marten was several times subwarden and later one of the bursars for years while holding the librarianship. Being bursar was no small task, especially if you chose to occupy that time, as John Marten did, with a kind of administrative guerrilla warfare, refusing to pay the warden's bills or to allocate funds to make repairs to the warden's lodgings. It is not surprising if the library was neglected. Scrutiny of the library funds was not tight, so it is plausible that Marten used the money earmarked for books to secure the support of younger fellows in his disputes with the warden. One of Marten's predecessors as librarian, Charles King (librarian 1709–15) was formally admonished three times for failure to account for library funds, but after his death in office there was no further mention of the matter.

Marten may have started out with good intentions. In the year of his appointment as librarian (1719) the college register records that fellows were reminded that the old library rules were to be 'strictly observed'. There is some evidence in the books themselves that the seventeenth-century practice of inscribing the names of those newly matriculated gentlemen commoners in books purchased with the fees they paid continued at least a few decades into the eighteenth century. Special acquisitions continued to receive attention, as attested by the surviving receipt for the £6 6s. subscription paid by Dr John Marten in 1724 'for Merton Coll: Library' for William

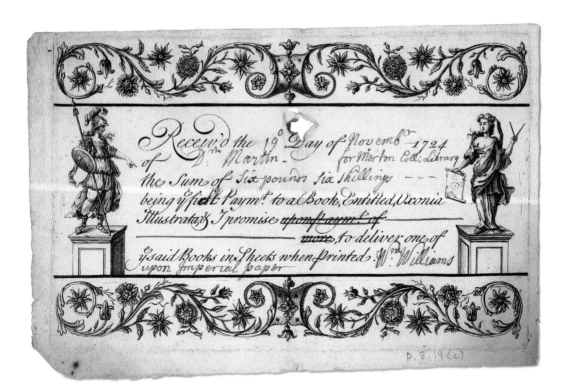

The production of costly publications was often funded by wealthy individuals and institutions paying an advance subscription. A few of these subscription receipts survive in the college library, providing some evidence that even in the relatively 'inactive' years of the first half of the eighteenth century, the college continued to acquire showy books. MS. D.3.19c.

Williams's luxury volume *Oxonia Depicta*. This is one of the few pieces of evidence of Marten's activity as librarian, though perhaps he deserves no special credit for this purchase, as he was instructed to do this on behalf of the college, and every Oxford college subscribed.

One has to feel sorry for the visitor, Archbishop John Potter, who finally had to come to Merton and put an end to the disagreements that were making the college dysfunctional. At the time of the visitation of 1738 there were only twenty-one fellows plus two chaplains. Several fellows were forced to leave the college. The college register contains a transcript of the archbishop's decisions and relates that Dr Marten was deprived of his fellowship, not for neglect of library duties nor for his irregular domestic arrangements, but because 'Dr John Marten now is and for many years last past has been possessed

of a more ample yearly revenue than ought to be held with his Fellowship' (MCR Register 1.4, p. 42) – an ancient provision rarely invoked, but one can imagine it was used with relief by the archbishop.

In the decades following the upsets of 1737–8, the library appears to have been run with a bit more order, although no one could call this a golden age. A worn and folded piece of foolscap paper from 1754–6 survives, marking the transition in the librarianship from the physician Gilbert Trowe to Henry Barton (Trowe died in 1756). The fees paid for the library by the various classes of new fellows and gentlemen commoners are recorded along with the amount already in the library budget. The total came to a healthy £115 14s. 9d.,

In the mid-eighteenth century the college acquired a new pair of globes: a terrestrial globe showing the latest geographical discoveries (part of the Australian coastline is depicted) and a celestial globe with beautifully illustrated constellations. Made by John Senex, FRS, and dated 1740, these were the largest globes obtainable commercially at the time, and they were an important addition to a scholarly library.

The major enterprise of publishing all the native flora of Denmark (and Danish territories) took 123 years, beginning in 1761. The Merton library acquired about half of the volumes before eventually ceasing the subscription. *Flora Danica* (Copenhagen, 1761–1883), pl. 1114.

of which £31 19s. 6d. had been expended in 1754–1756. The eleven titles in the list of books purchased include parts of multivolumed sets (which were being acquired as they were published) such as Viner's *General Abridgement of Law and Equity* and *The Parliamentary or Constitutional History of England* – essential library holdings. Dr Johnson's *Dictionary* also appears, as does the English translation of Guicciardini's *History of Italy*. And the college was continuing to keep up with the *Philosophical Transactions* of the Royal Society. These were expensive publications and the sort of thing that many college libraries were acquiring. Eleven titles in two years is very modest, but this sheet provides some evidence that an attempt was being made to keep the library up to a certain standard. In the same list of expenditure are the costs of binding and chaining the new books. Henry Barton seems to have started his tenure with the intention of maintaining a notebook of library expenditure but, following this initial accounting, there is a gap of 30 years before the next entry by a later librarian.

On 1 November 1792 the register of the college meeting reflected changes both global and domestic all lumped together in a single list:

It is agreed that the bursar be directed to pay into the hands of the Warden the sum of twenty-one pounds to be presented to the Vice-chancellor for the use of the distressed French Refugees now in England. Also that ten pounds be allotted out of Sympson's Benefaction towards the support and maintenance of Robert Turner a poor orphan aged 10 years. Also that the drain in the kitchen is examined … Also that the Librarian be desired to add one shelf to each Bookcase in the Library, and to take down one of the reading shelves in each compartment, Also that the chains be taken from the books, and that Mr Curtis be employed to make a compleat catalogue of the Library, and that the Librarian pay him for his trouble out of the money now in his hands belonging to the Library Fund. (MCR Register 1.4, p. 411)

The removal of one desk in each bay and the insertion of additional shelves at the end of the eighteenth century greatly increased the storage capacity of the library. Many of the eighteenth- and nineteenth-century books were smaller format than the large-format scholarly folios of preceding centuries. Shelves were later added under the remaining desks, which suggested that users were more likely to take books to the large table to consult them or to borrow them for use elsewhere.

This decision brought about the first major change in the physical arrangements and use of the library since Henry Savile introduced upright shelving over 200 years earlier. Although Merton was not the last of the Oxford colleges to remove chains from the library, by the end of the eighteenth century a chained library was an anachronism. The changes called for by the governing body also herald another shift that was not explicitly stated – for the first time the library became primarily a circulating collection. Only the medieval manuscripts and a few rare items were placed in locked cupboards. The new catalogue mentioned may have been an updated shelf list, which could be used as both a finding-aid and a kind of subject catalogue, since the books were shelved in broad subject groups with arts subjects in the west wing and medicine, law and theology in the south wing. If it was the plan that Mr Curtis (who was not a fellow and who does not make another appearance in the college register) compile a separate alphabetical catalogue with bibliographical details, it is doubtful that this happened, since the practice of annotating

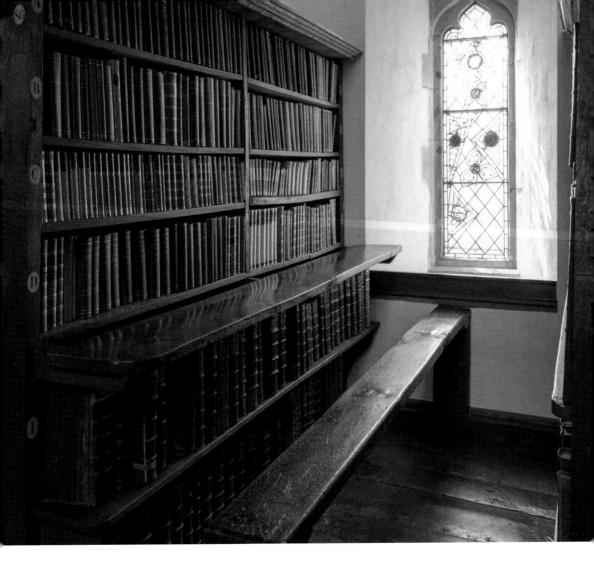

the old printed Bodleian Library catalogue continued well into the nineteenth century.

The call for a catalogue is in keeping with other administrative changes that took place about this time, but which are not recorded in the college register. For example, a separate record of library expenses was begun in 1790, perhaps introduced when the historian and antiquary Samuel Kilner became librarian in 1789. Similarly, once the books were

THE KANGOOROO.

Published as the Act directs June 15 1789. by J. Stockdale.

Kangaroo from *The Voyage of Governor Phillip to Botany Bay* (London, 1789), pl. 14. This illustrated account of the 1787 journey of the eleven British ships, known as the 'First Fleet', which carried convicts to New South Wales, was purchased by the Merton library in 1795 and frequently borrowed by fellows.

unchained, a large borrowing register was set up, probably placed in the library, so that fellows could enter the items they borrowed with the date of return.

The early pages of the loan register are now in a fragmentary state, but one can see that the first entry was made by the warden Scrope Berdmore, who borrowed the second volume of Dugdale's *Monasticon Anglicanum, or, The History of the Ancient Abbies, and Other Monasteries ... in England and Wales*, an appropriate choice given Berdmore's antiquarian interests. In the early years,

[following spread] One of the great luxury volumes purchased for the library at the end of the eighteenth century was the seven-volume illustrated folio Bible produced by Thomas Macklin. The biblical text was accompanied by seventy-two engraved illustrations specially commissioned from contemporary artists. The frontispiece to Genesis is by Benjamin West. The subscription cost was a princely £46 1s. Each volume was about twenty inches tall, and the whole set weighed over a hundred pounds. In the early years of the nineteenth century the Bible was housed in the librarian's room for safekeeping. *The Holy Bible* (Thomas Macklin, London, 1800).

only a few of the fellows were regular borrowers, and these loans reveal two different uses of the library. Some fellows borrowed books relevant to their academic interests. David Hartley, a future member of parliament, borrowed a number of legal texts, while Edward Nares, the first Regius professor of history, made use of theological works and editions of patristic texts. However, comparing the records of purchases and those of borrowing, one can see that certain works of travel and exploration (e.g., Phillips's *Voyage to Botany Bay* and James Bruce's *Travels to Discover the Source of the Nile*) were borrowed almost as soon as they were acquired and went out to several fellows when they were new. The college library could thus provide access to new and expensive publications of general interest that fellows may not have wished to purchase themselves. The most extreme example is the massive illustrated Bible produced by Thomas Macklin. Unlike botanical or travel works, one could not justify this purchase on scholarly grounds.

Additional insight into the development of the library in the late eighteenth century is offered by four volumes of sales ledgers from the years 1794 to 1800 of the Broad Street booksellers Fletcher, Hanwell and Parker (later commonly known as Parker's), which survive today in the Merton Blackwell Collection. These volumes list purchases by individual members and institutions associated with the university (colleges, the Bodleian, students and academics). Merton appears to have used Parker's primarily for acquiring periodicals and subscription items, such as *Philosophical Transactions* or the large botanical work Curtis's *Flora Londinensis*. The library at this time also administered the purchase of current journals for Merton's senior common room (*The Gentleman's Magazine, Monthly Review*). The purchases at Hanwell and Parker (as it was known from 1798) were therefore only a subsection of the library accessions, as is clear from a comparison with the library expenditure register for the same years. Even so, the Merton purchases contrast with those

B. West, R. A. Pinxt. London, Publish'd August 16ᵗʰ 1794 by Tho.ˢ Macklin Fleet Street. A. Hall, S.

MOSES

THE FIRST BOOK OF MOSES,

<p style="text-align:center">CALLED</p>

GENESIS.

CHAPTER I.

THE CREATION OF HEAVEN AND EARTH;
SUN, MOON, AND STARS; FISH AND
FOWL; BEASTS AND CATTLE; MAN IN
THE IMAGE OF GOD.

In the beginning God created the heaven and the earth.

2 And the earth was without form and void; and dark-ness was upon the face of the deep. And the Spirit of God moved upon the face of the waters.

3 And God said, Let there be light: and there was light.

4 And God saw the light, that it was good: and God di-

Lonicera Periclymenum.

Flora Londinensis, produced by the eminent botanist William Curtis and printed in London in the years 1777–98, sought to document all wild plants found within a ten-mile radius of London. The Latin and common names of the plants are included, but the real attraction of these volumes are the more than 400 detailed, hand-coloured engravings. Merton library purchased these through the bookseller Hanwell and Parker in the Broad Street, Oxford. The honeysuckle is from volume 3.

of some of the fourteen or so other colleges that also appear in the Hanwell and Parker accounts. While Merton spent an average of £5 to £6 a year (of a total expenditure of *c*.£30), in 1798 All Souls spent £118 at Hanwell and Parker alone. And, while Merton was using Hanwell and Parker for multivolume works published in parts, other colleges such as Christ Church were purchasing many more individual books.

By the end of the eighteenth century, the Merton library seems to have found some equilibrium with a new role as a lending library for fellows' academic work and the more recreational reading suitable for educated gentlemen. Essentially the structure of the building had remained unaltered since the 1620s, when the new windows were put in. Throughout the eighteenth century several Oxford colleges had built grand new libraries, of which the Codrington at All Souls and the new library at Christ Church received the most publicity, though not as many curious visitors as the Wren Library at Trinity College in Cambridge. In comparison with these vast light-filled rooms, the Merton library was small and dark. The original medieval features were not yet thought to be charming or atmospheric in a positive sense.

And what was happening with students during the same period? In the eighteenth century the small quadrangle acquired the name 'Mob Quad', probably on account of the rowdy undergraduate residents. The library, however, remained the privilege of the fellows and of the occasional guest. Merton seems not to have experimented with a students' reading room or a separate collection for undergraduates as some colleges did (Balliol for a period, as well as Trinity in Oxford and Trinity in Cambridge). Undergraduates still had to fend for themselves, although at least one anonymous alumnus thought of meeting this need sometime in the second half of the eighteenth century by donating a two-volume compendium of science to be kept by the college porter and made available for borrowing in the hall before dinner on Mondays. The students were asked to

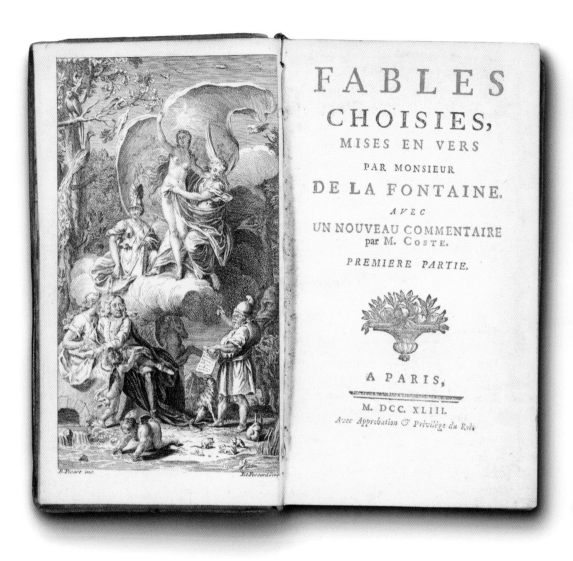

FABLES
CHOISIES,
MISES EN VERS
PAR MONSIEUR
DE LA FONTAINE.
AVEC
UN NOUVEAU COMMENTAIRE
par M. COSTE.

PREMIERE PARTIE.

A PARIS,

M. DCC. XLIII.
Avec Approbation & Privilége du Roi.

pay a two pence fine to the porter if they failed to return the
books on time. Whether this system was put into operation is
unknown. The books themselves are now in the library.

A gentleman's library?
Another hint that the idea of provision for the undergraduates
was at least in some minds is contained in a clause in the will

Henry Kent's bequest enhanced the holdings of the Merton library by adding European literary works, such as the fables of La Fontaine in French, with engraved frontispieces. *Fables choisies, mises en vers par Monsieur de La Fontaine* (Selected fables, put into verse by Monsieur de La Fontaine) (Paris, 1743).

drafted in 1775 of former fellow Dr Henry Kent (1718–99). Kent, a country clergyman, wished to leave £300 that might be used, among other possibilities, for 'buying books towards establishing a Library for the use of the undergraduates'. Unfortunately there seems to be no mention of a bequest of £300 in the college records following Kent's death, so the monetary bequest may not have materialized. At the same time, Kent's will also refers to the bequest of 'all my printed books which I will shall remain in the said college for the use of the undergraduates of the said society'. Over 800 volumes did arrive at Merton and were absorbed into the college library without any mention of undergraduate use.

Kent's books brought Continental literature and history to Merton, with literary classics in French, Spanish and Italian, as well as dictionaries in those languages. Some of these are in early editions, others in smaller-format eighteenth-century editions, of the sort that one would find on the shelves of a country house library. These were the type of books that Merton fellows and well-off students might well have had in their personal collections but that would not previously have been acquired by the library. The acceptance by the college of Kent's books was to prove a wise decision, as the nineteenth century brought about changes in the Oxford curriculum. By the end of the nineteenth century undergraduates could study post-classical history and literature, and they could even use the college library.

Nineteenth and early twentieth centuries 6

A library for undergraduates and a historic monument

Each of the central panels of the sixteenth-century German glass depicts a scene from the Passion of Christ. The original setting of these panels is still unknown, although the names of donors visible in some panels indicate that the Rhineland is likely.

One of the most striking features of the library today is the golden glow of the stained glass in the oriel window at the east end. The glazing was designed in 1841 to complement a set of twelve sixteenth-century German panels acquired by the librarian Edward Bigge and presented by him to the college. The late-medieval scenes from Christ's last days are set into nineteenth-century glass with 'WM' monograms referring to Walter de Merton. At either side, decorative cartouches and inscriptions commemorate Walter de Merton as founder of the college and author of the 1274 statutes (the third and last set of statutes authored by Walter before his death in 1277). The impressive window uses colour to unite the imported late-medieval glass with otherwise unrelated references to the college's foundation.

'The recording of a brilliant past'

For a decade or so, it appeared that subsequent college librarians followed Bigge's example by personally sponsoring new stained glass and initiating a programme of commemorative windows.

In 1858 Edmund Hobhouse, former librarian, busied

himself writing to Mertonians about a project in the college library that he was anxious to promote before he himself left for a position in New Zealand. He wrote:

> I have commenced a series of commemorative windows in our Library for the purpose of recording the greater names that have reflected glory upon the House of Merton by their literary renown ... I hope that her past and her future may both be pleaded as a claim on the affections of her alumni, and certainly the recording of a brilliant past tends greatly to create a glorious future and an immediate Esprit de Corps. (MS. Q.2.4(iv))

The first two windows in this series related directly to the history of the library, commemorating William Reed and Henry Savile, while the others (at a cost estimated by Hobhouse of about £5 each) memorialize the founder Walter de Merton, the medieval Merton philosopher Thomas Bradwardine, the fourteenth-century college benefactor John Wyliot and a more recently deceased fellow William Adams (d.1848).

Who were the intended beneficiaries of the visual encouragement provided by the memorial windows in the library? In 1827 the college had taken the bold step of opening the library to undergraduates for one hour per week. This probably didn't disturb the peace of the room, since for the first half of the century there were fewer than thirty undergraduates in the college in any given year. The situation at Merton was not unusual at the time, but all this was about to change. The University Reform Commission was set up in 1851, leading to the Oxford University Act of 1854 and a series of reforms in the following decades that changed governance, made the university more meritocratic, increased the number of undergraduates and introduced new subjects of study. There was a flurry of new building in many of the older colleges. At Merton, plans for expansion almost resulted in the destruction of the library.

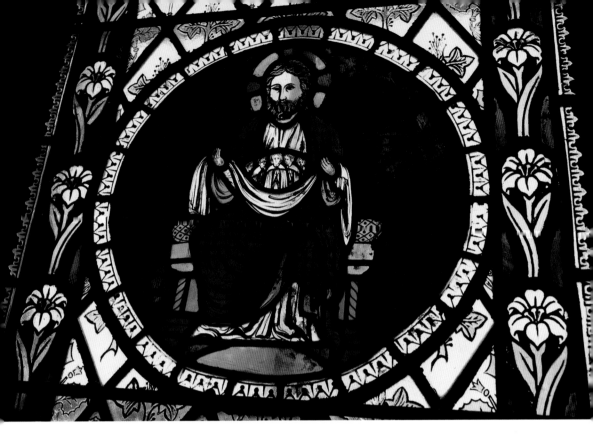

The nineteenth-century stained glass in the large south window evokes the college's history with compositions based on the earliest college corporate seal. Christ is shown seated, holding little figures representing the souls of deceased Mertonians in a draped cloth.

'Vandalism in Merton'

In June 1861 fighting had begun between the northern and southern states in America, but the letters pages of *The Times* reveal another struggle, which was taking place at Merton. At issue was the fate of the old library and the Mob Quad. Driven by the need to create accommodation for the additional undergraduates in the spirit of enthusiastic reform, the majority of fellows decided in May 1861 that some alteration and addition to Mob Quad offered the best solution. The convoluted wording of the minutes of the college meeting hint at opinions being divided, especially in regard to the old library. The fellows agreed 'that it is not inexpedient to remove any portion of the library ... that the College will not decline to take into consideration a plan which involves the destruction

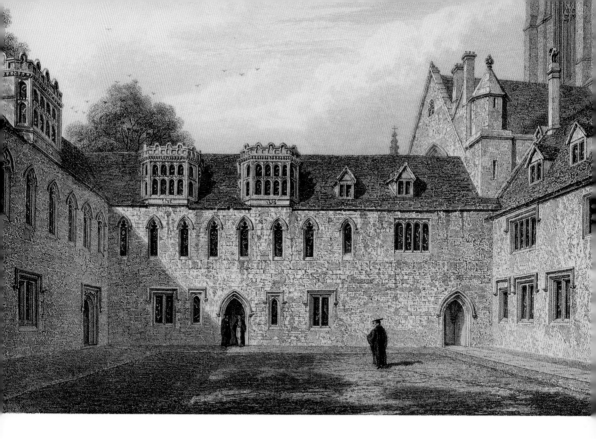

of Mob Quadrangle'. As if to confirm the point, the minutes continue, 'it being understood that the College is agreed to the entire demolition (if necessary) of Mob Quadrangle' (MCR Register 1.5, p. 403).

At this point the college was in discussion with the renowned architect William Butterfield (who had re-Gothicized the college chapel in the 1850s). One plan involved swinging the south wing of the library 180 degrees to open out the quadrangle towards the old city wall, creating space for the formation of a new quadrangle. At the June 1861 college meeting, however, the subwarden gave notice that in the autumn he would 'ask the College to reconsider its recent decision with respect to the college library, with a view to the preservation of the Library intact under all circumstances'. Just a few weeks later, during the summer vacation, the

The antiquarian J.H. Parker, who was later to fight the destruction of Mob Quad, published this engraving of the exterior of the library in 1833. MCPr/B/75.

college debate expanded into the national press and was being discussed by local and national preservation and architectural heritage groups.

The emotional language of the discussion was critical of both Butterfield and the fellows of Merton, employing words like 'barbarity,' 'wanton destruction' and 'vandalism': 'Can nothing be done to save the library?' Butterfield feared that the Merton fellows might be influenced by what he called 'clamour', but almost certainly some of the fellows had a part in stirring up the protest about Mob Quad and the library. On 31 October 1861 the fellows passed the resolution 'That the decision of the 22 [sic] May last with reference to the possibility of removing the Library be rescinded'. The college decided instead to create more undergraduate rooms by commissioning Butterfield to build an entirely new building (now Grove Building). The Mob Quad library had become an acknowledged 'venerable' historical structure whose value was recognized beyond the college walls, and it was celebrated in 1864 with a double-aspect engraving in the *Illustrated London News* accompanying an article about Merton's six-hundredth anniversary.

Having publicly decided to keep the library, the college had to do something about preserving it, but it hardly rushed the work, the roof finally being repaired (by G. Gilbert Scott) in 1870.

The college still needed to do something to address the academic needs of the recently increased number of undergraduates. Up until the mid-nineteenth century undergraduate education was essentially classical languages, literature and history, with perhaps a bit of mathematics, and both teaching and examining could be rather lax. (Warden Brodrick wrote in his *Memories and Impressions* that the elderly fellows still in residence when he was elected in 1855 regarded the college 'not exactly as a place of education, but rather as a pleasant resort' (pp. 110–11).) Courses of study introduced in the nineteenth century included natural sciences, history, English and modern languages. Students (increasingly

admitted on academic merit) were required to attend the lectures given by professors and to pass more rigorous examinations. The college library began to be considered as a resource of use to students and not just a privilege for fellows.

Student access to the college library increased slowly from the one hour per week. As late as 1883 the library was open to students for two hours a day, three weekdays per week, and by 1897 the library was open three hours every weekday morning. There is a reference in 1871 to a room being established as an undergraduates' library (location not specified) and in 1877 the room beyond the west door of the Upper Library (now the Beerbohm Room) was used as a reading room. The chapel sacristy, on the ground floor at the entrance to Mob Quad, was refurbished as a reading room with shelving in 1901. Finally in 1906 the library expanded into the ground floor of Mob Quad (previously residential accommodation) with the Brodrick Reading Room, to which more ground floor space was added in 1928–9.

At the same time as the use of the library changed, the number of books purchased for the library increased and the range of subjects widened, although there was still a concentration on classics and history. The lists of purchases from the second half of the nineteenth century do not survive, but the fellows' loan book does. The increase in loan activity is noticeable. Borrowing by fellows increased from a total of around forty items per year in the late 1790s to around 130 per year in 1873. While travel accounts, memoirs, sermons and theological works were the most commonly borrowed subjects in the 1790s, more commentaries on individual classical works and European history, as well as some French and German literature, were borrowed in the 1870s. (William Esson, the mathematics tutor, borrowed several volumes of Schiller; more predictably the historian Mandell Creighton was borrowing the works of German and French historians.) One gets the impression that the fellows were using the library for academic

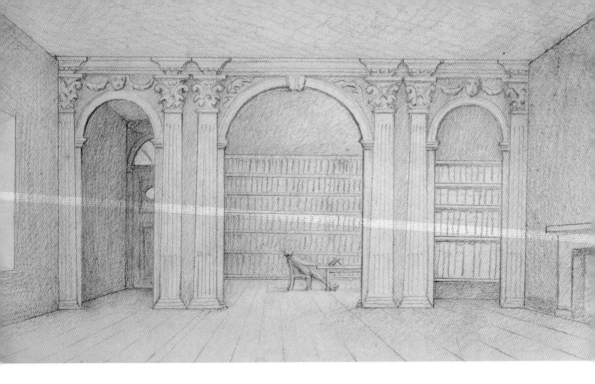

reading, perhaps to prepare for teaching and as more than an adjunct to their ample private libraries.

Jay Gatsby's 'Merton College Library'

Within the space of the nineteenth century, the original features of the Merton library, which had seemed so old-fashioned and dark, became increasingly valued as a rare survival of something truly medieval and not just a Gothicization. Oxford guidebooks often gave it a brief mention, even if it was not generally open to the public. It is true that the young brother and sister in the moralizing guidebook of 1820 *The Young Travellers* are more taken with 'the skeleton of a man near seven feet high' (probably the same skeleton mentioned by Uffenbach). But Joseph Wells's popular guidebook *Oxford and its Colleges* calls it 'undoubtedly the most interesting medieval library in England', adding that 'some of the old fittings with their chained books are still preserved' (p. 74). Visitors to the

library who were not academics could be taken round by friends connected to the college.

An evocative account of an informal visit is provided by the children's author Beatrix Potter, who was eighteen at the time and was attending a garden party at Merton. Her storytelling skills are already evident in her diary entry recording her visit on 9 June 1884:

> Mrs Wilson showed us over the Chapel, and the kitchen, and a most interesting library. One of the oldest buildings in Oxford with a most beautiful oak roof, and the original tiles on the floor.
>
> There was no one there, and we looked at the old books, and did not hurry, which I have come to the conclusion is a necessary part of the enjoyment of sightseeing. The library is said to be haunted by old Lord Chancellor Merton, the founder, who was killed by his students with their pens.
>
> It certainly was very silent, and there was the ancient, dusty smell so suggestive of ghosts. Then at last, heavy steps, and the sound of a stick on the stairs at the further end, pat pat, nothing visible, but it proved a little fat old lady, a very sociable ghost. (*The Journal of Beatrix Potter from 1881–1897*, p. 90)

By 1920 *Alden's Oxford Guide* says the library was open from 11 a.m. to 4 p.m. (a small gratuity was charged). Fletcher's 1915 *Handy Guide to Oxford, Specially Written for the Wounded* (the wounded servicemen in the hospital in the Exam Schools building) advises: 'If ... there is one distinctive thing in Merton it is the Library, in which you may actually see the old desks and the staples to which the books were chained' (p. 43).

The reputation of Merton's library as representing 'the medieval library' resulted in the creation of an unusual doppelgänger at Princeton. When the American architect Charles McKim designed a distinctive library room for the

[opposite] This watercolour from the Merton collection depicts the library as it may have appeared about the time of Beatrix Potter's visit. The Upper Library was painted twice in the late nineteenth or early twentieth century by the Oxford-based watercolourist Frances Drummond.

[following spread] In 1903 the American architect Charles McKim recreated the Merton College Library for the new Cottage Club building at Princeton University.

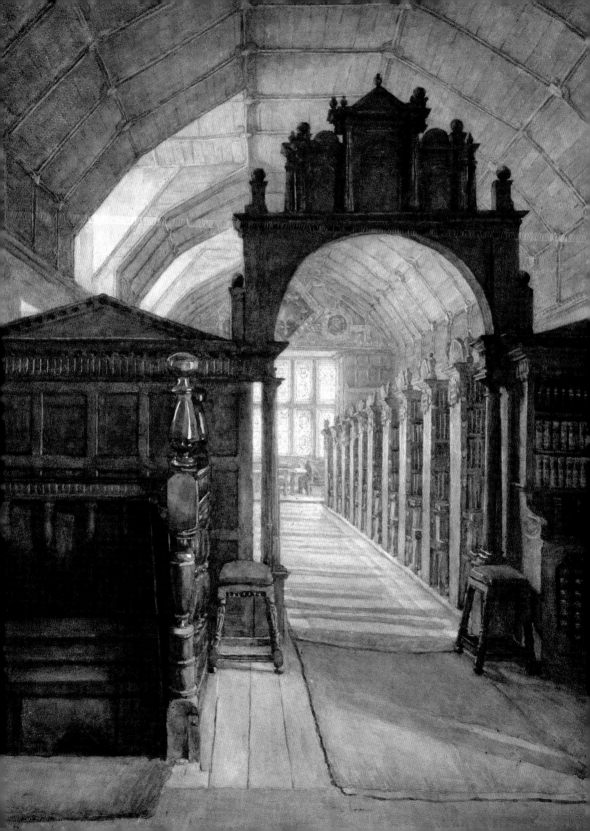

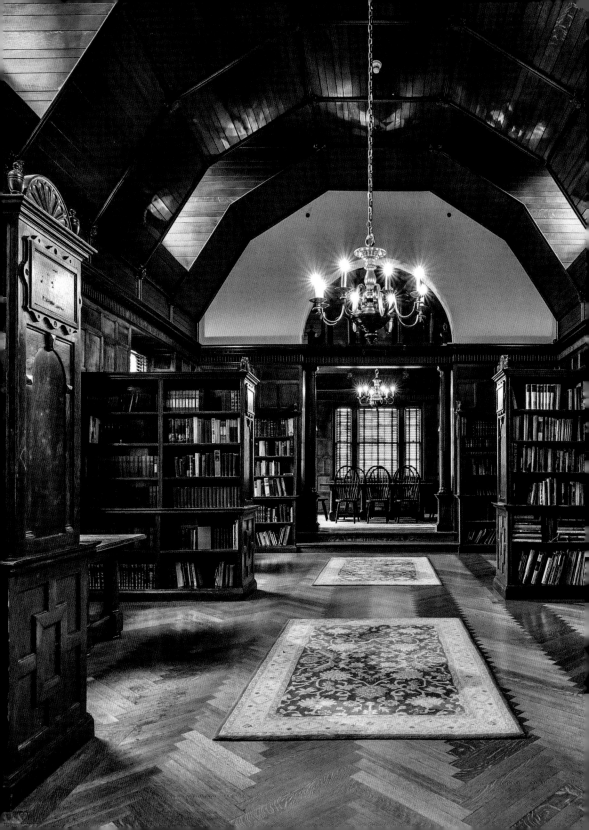

private undergraduate club, the Cottage Club, in 1903, no expense was spared. An English dealer was commissioned to measure the interior of the Merton library and to supply English oak from which McKim could create an adapted, more comfortable, reproduction of one of the wings of the Merton library as the club's library.

It is not surprising then, that in F. Scott Fitzgerald's 1925 novel, *The Great Gatsby*, one of the rooms in Jay Gatsby's mansion is referred to by the narrator, Nick Carraway, as his 'Merton College Library' (in quotes). The point is not whether Gatsby's library is a reproduction of Merton's, but that, along with many of the rooms in Gatsby's house (e.g., the Marie Antoinette room), the oak-panelled library is an imitation – although as one of his guests observes in surprise, the books in it are real. Like the library in the Cottage Club, Gatsby's library is a bragging point. The mansion reflects the character of its owner – the reader and the narrator do not know what is real and what has been faked for expensive effect. Fitzgerald, a Princeton man, obviously assumed that at least some of his readers would catch this pointed comment referring to Gatsby's pretensions. Merton's library had become a byword for the 'best' ancient library.

Although the Upper Library, or Old Library, was still functioning as part of the college library in the 1920s, it was more and more used as a historic space for the preservation of the older books and valuable objects. This aspect of the Upper Library was further enhanced later in the twentieth century, while the modern collections for the increasingly academically ambitious undergraduates were expanded in another location.

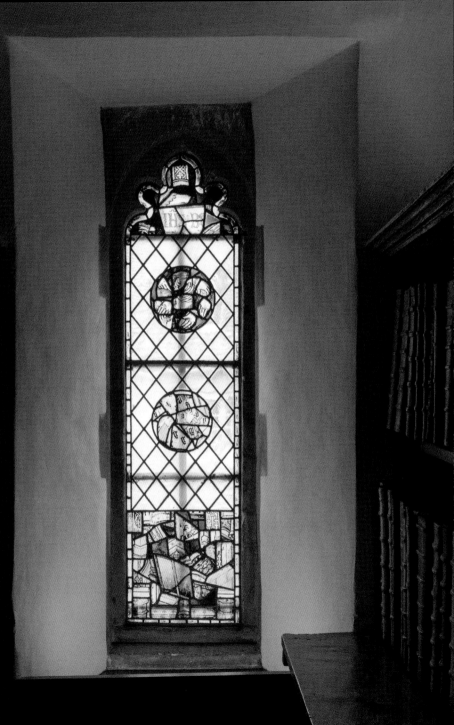

Twentieth century and beyond

7

Heritage collections

In the postwar years, over a period of more than fifteen years, fragments of stained glass from the chapel transepts (already fragmentary from earlier damage) were installed in the Upper Library windows, creating some colourful and rather bizarre designs.

In one of the first changes to library administration since the establishment of the librarian in the seventeenth century, the college agreed in 1897 to institute a library committee comprising the librarian and three fellows. The main responsibility of this committee was to approve book purchases. The level of activity of the committee varied; there were times when the handwritten minutes record that the librarian himself was the only member present. At other times, however, the library committee drove forward repairs to structure and to books, and the creation of reading rooms.

Reading rooms with shelving for open-access library books were located in several places around the main college site in the first half of the twentieth century. It took a while for reading rooms to occupy the entire area underneath the medieval library in Mob Quad. A reading room named for Warden Brodrick (who as a younger man helped save the medieval library from destruction) was completed in 1906–15. This was followed by the opening in 1929 of an adjacent room, partly to accommodate books bequeathed by the Hegelian philosopher and fellow F.H. Bradley. It wasn't until

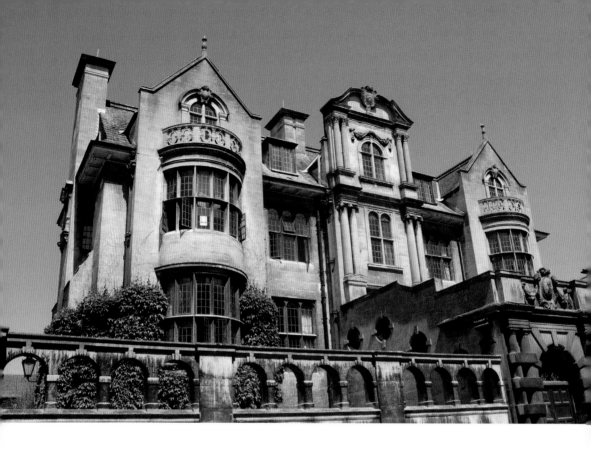

the late 1950s, however, that part of the kitchen storage area in the south wing of Mob Quad was added to the lower library space. About the same time a law library room and a science library room were opened in the Old Warden's Lodgings on the north side of Merton Street. These rooms provided a core that was expanded in the 1990s when three floors of the building were converted to library space, along with a staffed issue desk. Opening hours in the second half of the century extended to 11 p.m., except on those few occasions when the librarian was authorized to close the library early when he had 'reasonable grounds for anticipating riotous assembly and rout [i.e., Commemoration balls, Bonfire Night and other such occasions]' (typescript memo inserted in MCR Library Register I, p. 334).

OWL, the Old Warden's Lodgings designed by Basil Champneys and built in 1904–5. The library reading rooms enjoy the large bay windows, elevated so that the warden would not have to live in the shade of the college walls on Merton Street.

More books, more loans and more reading rooms to look after also meant more staff. Until 1994 the position of librarian, whose responsibilities included the archives, continued to be held by a fellow mainly engaged in teaching undergraduates. An assistant librarian did most of the hands-on work with the help of a library clerk and sometimes students. In 1941 L.J. Francombe retired after 45 years as assistant librarian. He was probably glad that he had taken this step when he did, as in 1942 the library committee took the decision that, due to the 'necessity of economizing fuel, the heating of the reading rooms [be] discontinued'. This chilly period lasted until October 1945, when a brief entry in the library register says simply: 'Heating Restored'. With the appointment of the first woman librarian, Sarah Bendall, in 1994 (the same year in which the first woman warden was elected) the college established a full-time professional fellow librarian, and it was not long before a professional archivist was added to the library staff.

Special collections and the 'historic library'

The expansion of the library into the ground floor of Mob Quad with new reading rooms led to a gradual focusing on the

The *Oxoniam quare* window was moved from a Mob Quad bedroom to the Upper Library for safety in the late nineteenth century. The inscription translates as: 'You have come to Oxford for the purpose of study. / So by night and day be vigilant and don't waste your time.'

Upper Library as a historically significant space and also as a place in which valuable artefacts could be preserved. Already in the late nineteenth century, the stained glass inscription reminding the viewer to 'Remember why you came to Oxford' had been moved from a student bedroom in Mob Quad to the library as a place of greater safety. A seventh-century BCE Assyrian cuneiform-inscribed stone tablet was presented to the college in 1928 and could henceforth be cited as the oldest written record in the library.

The classicist and professor of poetry, fellow librarian from 1925 to 1951, H.W. Garrod, was responsible for several initiatives to enhance the Upper Library. He conducted research into and published on the history of the library in the Middle Ages. One of his first structural projects was reconfiguring the shelving above the reading desk in the first bay of the south wing, which already housed the two remaining chained books, to restore the original seventeenth-century arrangement. During the war years, the medieval manuscripts and the medieval stained glass were moved to the safekeeping of the Bodleian Library underground stacks. But after the war Garrod resumed work on the library, overseeing the creation of new stained glass windows that incorporated fifteenth-century glass fragments from the chapel. In 1955 a collection of mostly seventeenth- and eighteenth-century books previously kept in the warden's lodgings was incorporated in the Upper Library along the wall of the east end.

Fellows and former students continued the tradition of presenting their publications and rare books to the college

In the seventh century BCE, the king of Assyria Ashurbanipal enlarged the temple of the god Nabu in Nineveh. This inscription from the temple records that, with Nabu's support, Ashurbanipal captured his enemies and harnessed them to his royal state carriage. The tablet was presented to the college by the archaeologists R. Campbell Thomson (fellow) and R. W. Hutchinson in 1928. Appropriately, Nabu was the god of writing, literacy and wisdom.

Restoring Savile's library stall. A postcard from around the early 1930s shows the shelving of the first bay in the south wing with two chained books prior to the restoration work of 1933. The restoration moved the central shelf with the chaining bar back to its original position.

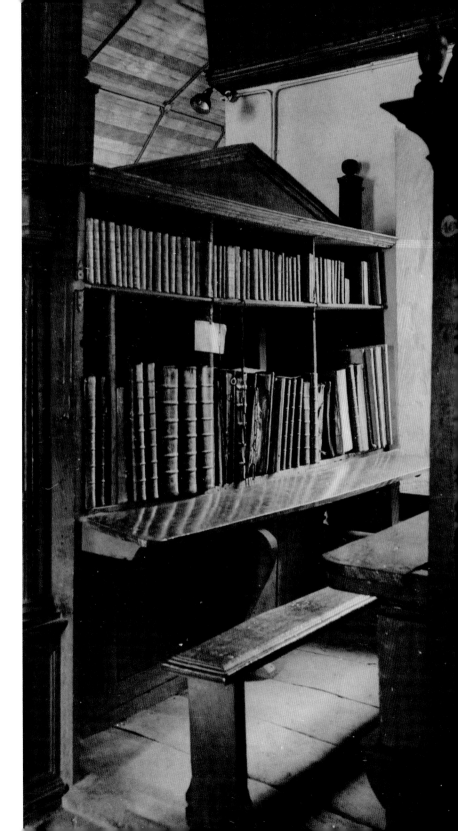

library, although the requirement for fellows to bequeath their entire libraries had died away during the sixteenth century. Few former students made individual contributions like those of the bookseller and publisher Basil Blackwell (1889–1984). Blackwell had studied classics at Merton before taking on the family bookshop in Oxford and building it into a major publishing and bookselling business and Oxford landmark. In 1951 he presented the library with a copy of the first printed edition of the works of Aristotle in Greek (1495–8). A few years later, with the encouragement of the new librarian (Roger Highfield), Blackwell began a tradition of annual gifts of significant early printed books (often Greek and Latin texts printed in the fifteenth century).

[above] Max Beerbohm's messy paintbox, as it was left at his death and presented to Merton. Beerbohm Collection 2.11.

[opposite] 'The Theft, 1894' and 'The Restitution, 1920'. This pair of humorous watercolours by Max Beerbohm depicts the artist as a young man sneaking a book from the Mob Quad library in 1894 and returning it as a venerable bearded old man in 1920. Beerbohm Collection 8.4 and 8.4a.

The second half of the twentieth century also saw a shift towards acquiring larger heritage collections – usually with a connection to past Mertonians – which the library could preserve and make available to researchers. The most extensive of these was the collection of drawings, manuscripts, correspondence, and annotated books from the estate of the critic and caricaturist Max Beerbohm (1872–1956). A first gift of items from Lady Beerbohm was followed at her death by more material, which in turn attracted further donations from others. The college celebrated this major series of acquisitions in 1961 by designating a room in which selections from the collection could be displayed. The Beerbohm Room was located in the formerly residential room across the landing from the west wing of the Upper Library – the same room from which

The Theft. 1894

The Restitution. 1920.

the subwarden had administered the library centuries earlier.

A much less extensive but equally evocative collection is the personal archive of photographs, letters and artefacts left by Andrew (Sandy) Irvine following his death at the age of twenty-two on the 1924 Everest expedition led by George Mallory. Irvine's Everest diary (a very modest black notebook) was given to the college in 1962 by his brother, and a large amount of newly rediscovered material was added by the Irvine family in 2011. The collection also includes memorabilia marking Irvine's brilliant success as an oarsman, but it is the Everest diary, letters, photographs, packing lists and a small pressure kettle for brewing tea at high-altitude camps that bring this archive to life.

[above] Detail from the fifteenth-century glass incorporated in the Upper Library windows in the twentieth century.

[opposite] The Sandy Irvine Archive includes artefacts such as this small pressure kettle, made to Irvine's specification to boil water for tea even at high altitude.

In the twentieth century the college actively sought to add to the holdings of first editions of Mertonian poets such as Edmund Blunden, Louis MacNeice and in particular T.S. Eliot, who had studied at Merton in 1914–1915. Hundreds of Eliot's publications, from first editions to single poems and essays that appeared in magazines, were bequeathed to the college by the alumnus Frank Brenchley in 2011.

The early years of the twenty-first century also brought the establishment of the Merton Blackwell Collection, donated to the college by Basil's son Julian. This extensive collection of Oxford's premier bookselling business constitutes a rich mine of information for historians of the book and of bookselling, including not only family papers but business records of Blackwell's and also of the historic Oxford bookseller Parker's (later acquired by Blackwell). A sister collection, the Blackwell Publishing Archive, is held in the Bodleian Library.

Afterword

The Library at Merton College was never just one building or space, but something shared and dynamic. Originally it was a collection of books formed by fellows and benefactors for the use of fellows. Over the centuries fellows and alumni supported and maintained it; the collections and the library building were and remain community endeavours. The decoration of the interior of the library building manifests institutional pride, but it was always a place for use rather than show. The Upper Library can appear at first glance to be unchanging but it is neither a fossil nor a re-creation. What is unchanging is not the structure but the academic purpose. At the heart of the college for more than 700 years, it is shared with more people than ever before through research, visits to the Upper Library, and through online resources. The library reading rooms are a peaceful sanctuary but also places of exploration and discovery. It did not survive by chance. No other academic library today was founded so early, while also continuing to function today as a focal point of intellectual community life.

Sources and Further Reading

Aubrey, John, *Brief Lives*, ed. Kate Bennett, 2 vols, Oxford University Press, Oxford, 2018.

Ayers, Tim, *The Medieval Stained Glass of Merton College, Oxford*, Oxford University Press, Oxford, 2013.

Barber, Giles, *Arks for Learning: A Short History of Oxford Library Buildings*, Oxford Bibliographical Society, Oxford, 1995.

Bott, Alan, *Merton College: A Longer History of the Buildings and Furnishings*, Merton College, Oxford, 2015.

Brockliss, L.W.B., *The University of Oxford: A History*, Oxford University Press, Oxford, 2016.

Brodrick, George C., *Memories and Impressions*, James Nisbet & Co., London, 1900.

Clapinson, Mary, *A Brief History of the Bodleian Library*, Bodleian Library, Oxford, 2015.

Fletcher, C.R.L., *A Handy Guide to Oxford, Specially Written for the Wounded*, Oxford, 1915.

Gameson, Richard, 'The Medieval Library (to c.1450)', in Elisabeth Leedham-Green and Teresa Webber (eds), *The Cambridge History of Libraries in Britain and Ireland*, vol. 1: *To 1640*, Cambridge University Press, Cambridge, 2006, pp. 13–50.

Garrod, H.W., 'The Library Regulations of a Medieval College', *The Library*, 1927, pp. 312–35.

Gunn, Steven (ed.), *Treasures of Merton College*, Merton College, Oxford, and Third Millennium Publishing, London, 2013.

Henderson, Bernard W., *Merton College*, F.E. Robinson, London, 1899.

The History of the University of Oxford, 8 vols, Clarendon Press, Oxford, 1984–94.

Ker, N.R., 'Oxford College Libraries in the Sixteenth Century,' *Bodleian Library Record*, vol. 6, 1959, 459–515.

Ker, N.R., 'The Provision of Books,' in T.H. Aston (gen. ed.), *History of the University of Oxford*, vol. 3: *The Collegiate University*, ed. James McConica, Oxford University Press, Oxford, pp. 441–97.

Lovatt, Roger, 'College and University Book Collections and Libraries', in Elisabeth Leedham-Green and Teresa Webber (eds), *The Cambridge History of Libraries in Britain and Ireland*, vol. 1: *To 1640*, Cambridge University Press, Cambridge, 2006, pp. 152–77.

Martin, G.H., and J.R.L. Highfield, *A History of Merton College*, Oxford University Press, Oxford, 1997.

Morrish, P.S., 'Dr Higgs and Merton College Library: A Study in Seventeenth-Century Book Collecting and Librarianship', *Proceedings of the Leeds Philosophical and Literary Society, Literary and Historical Section*, vol. 21, 1988, pp. 131–201.

Potter, Beatrix, *The Journal of Beatrix Potter from 1881–1897*, transcribed by Leslie Linder, F. Warne, London, 1966.

Powicke, M., *The Medieval Books of Merton College*, Oxford University Press, Oxford, 1931.

Registrum Annalium Collegii Mertonensis, 1483–1521, ed. H.E. Salter, Oxford Historical Society, lxxvi, Oxford, 1921; *1521–1567*, ed. J.M. Fletcher, Oxford Historical Society, n.s. xxiii, Oxford 1974; *1567–1603* ed. J.M. Fletcher, Oxford Historical Society, n.s. xxiv, Oxford, 1976; *1603–1660*, ed. J.R.L. Highfield, Oxford History Society, n.s. xxxix, Boydell, Woodbridge, 2006. [All citations in this book are to the original register in Merton College.]

Thomson, R.M., *A Descriptive Catalogue of the Medieval Manuscripts of Merton College, Oxford*, Boydell & Brewer, Cambridge, 2009.

Thomson, R.M., 'William Reed Bishop of Chichester (d.1385)—Bibliophile?' in George Hardin Brown and Linda Ehrsam Voigts (eds), *The Study of Medieval Manuscripts of England: Festschrift in Honor of Richard W. Pfaff*, Arizona Studies in the Middle Ages and the Renaissance (ASMAR), Tempe, AR, 2010, pp. 281–93.

Thomson, R.M., and J.G. Clark, *The University and College Libraries of Oxford*, Corpus of British Medieval Library Catalogues, 16, British Library in association with The British Academy, London, 2015.

Uffenbach, Zacharias Konrad von, *Oxford in 1710*, in *Travels of Zacharias Conrad von Uffenbach*, trans. W.H. Quarrell and W.J.C. Quarrell, Blackwell, Oxford, 1928.

Wells, Joseph, *Oxford and its Colleges*, Methuen & Co., London, 1897.

Wood, Anthony à, *The Life and Times of Anthony Wood … collected from his diaries by Andrew Clark*, vol. 1, Oxford Historical Society, Oxford, 1891.

Unless otherwise stated, all manuscripts, early printed books, pictures and other resources are from the Merton College collections. References to Merton archival documents are to the originals and not to published versions.

Acknowledgements

This work was inspired by the many questions of visitors to the Merton Library. A book of this sort would not be possible without more specialized studies by other scholars, some of them my predecessors as Merton Librarian, and to whom I am greatly indebted. I will mention in particular the work of Percy Allen, Tim Ayers, Sarah Bendell, Alan Bott, Mary Clapinson, H.W. Garrod, Roger Highfield, P.S. Morrish, Maurice Powicke and Rodney Thomson.

For continuing help and advice I am grateful to David d'Avray, Colin Dunn, Julian Reid, a learned anonymous reader, and the Bodleian publications team, especially Samuel Fanous, Janet Phillips and Leanda Shrimpton. I am thankful for the support of the Warden and Fellows of Merton College, Oxford, and of the library staff.

Picture Credits

Unless indicated, all images are © The Warden and Fellows of Merton College, Oxford.

Principal photography by Colin Dunn, Scriptura Ltd.

Index